NAAMA TSABAR
(OPUS 1)

MP

FAENA ART CENTER BUENOS AIRES
KUNSTHAUS BASELLAND
CCA TEL AVIV

A special thank to Sara Tsabar, Hai Tsabar, Tali Shamir, and Sarah Strauss for their endless belief and support.

AAMA TSABAR (OPUS 1)

FOREWORD

Alan Faena, <small>Faena Art Center Buenos Aires</small>
Ines Goldbach, <small>Kunsthaus Baselland, Muttenz / Basel</small>
Nicola Trezzi, <small>CCA – Center for Contemporary Art Tel Aviv</small>

or more than a decade, installation and performance artist Naama Tsabar has been employing everyday materials to form experiential and conceptually charged works of art that explore questions of power, sensuality, and memory. Through the appropriation and subversion of objects and iconic gestures from the realms of art and music—and their associations with masculinity, patriarchy, virility, and power—Tsabar upends the implicit gender roles and coded behaviors established by mainstream history and society. Following her solo exhibitions *Melodies of Certain Damage (Opus 2)* at Faena Art Center in Buenos Aires, *Transitions #4* at Kunsthaus Baselland in Muttenz/Basel, and *Melodies of Certain Damage (Opus 3)* at CCA – Center for Contemporary Art Tel Aviv, this book not only documents these exhibitions but it provides, for the first time, a deep reading and interpretation of her multi-faceted practice, which encompasses sculpture, photography, sound, and performance.

The essay by Chen Tamir, curator of the Tel Aviv exhibition, gives an over-view of Tsabar's practice, including a look into her photographic works. In an interview with Ines Goldbach, curator of the Basel exhibition and author of the text on the *Transition* series, the artist shares insights about works from the Kunsthaus Baselland exhibition and talks about seminal works, such as *Propagation (Opus 3)* and *Untitled (Speaker Walls)*. Zoe Lukov, who curated the Buenos Aires exhibition, focuses on the artist's latest series of sound and performative installations—also presented in Tel Aviv—with additional reflections on what Tsabar called "the workshop," the intense preparations by the artists and performers involved in the composition and execution of the score conceived for each installation.

This book was made possible through the will and enthusiasm of many individuals. First, we must acknowledge the contributors who translated their firsthand experiences of Tsabar's practice into words. Our gratitude goes to all the donors, foundations, and grantssupporting the three exhibitions and this book: the Artis Grant Program, the Isaac Dreyfus-Bernheim Stiftung, the Dr. Georg und Josi Guggenheim Stiftung, Giora Kaplan, the Mifal HaPais Council for the Culture and Arts, the Ostrovsky Family Fund (OFF), OUTSET Israel, Thomas Rom, Marc Schimmel, and the Ruth und Paul Wallach Stiftung. Additional thanks to the artist's representing galleries: Dvir Gallery, Tel Aviv / Brussels; Kasmin, New York; Shulamit Nazarian, Los Angeles; and Spinello Projects, Miami. Finally, we would like to extend our heartfelt thanks to Naama Tsabar, whose energy, integrity, ambition, and determination has made these exhibitions and this book a unique opportunity to reflect on the ways we experience reality—alone and with others.

TURNING SOUND INTO SPACE

Chen Tamir

first learned how to use a drill when I moved into my first
apartment in Tel Aviv, nineteen at the time. My father helped
me put up shelves in my room. He explained the process—
how one must hold the drill, what size anchor one must use for
the screws, and what size hole should be made for the anchors.[1]
Naama Tsabar

One is not born, but rather becomes, a woman.[2]
Simone de Beauvoir

The view that gender is performative sought to show that what
we take to be an internal essence of gender is manufactured
through a sustained set of acts, posited through the gendered
stylization of the body.[3]
Judith Butler

Naama Tsabar creates tactile installations, performances, and sculptures
that parse the boundaries of spaces that surround us—be they
physical or metaphorical—but to which we normally have no ac-
cess. To investigate how this is accomplished, this essay will focus
on two broad bodies of work: sculptures that double as musical
instruments and whole spaces that are transformed into instru-
ments. In the process, this essay will touch on how Tsabar evokes
questions of power through performance, how she draws on the
history of Minimalism, and how she upends gender binaries.

Tsabar's sculptural works are particularly focused on generating, or suggest-
ing, a hyper sense of intimacy. For example, *Untitled (Double
Face)* (2010) is a sculpture made of two guitars fused together at
their backs. When activated in performance, two musicians face
each other: Tsabar herself, who is right-handed, and her long-term
collaborator, Kristin Mueller, who is left-handed. As the two hold
the instrument between them, they must negotiate not only
the production of music, but how they move throughout the space
as they perform, how they intuitively communicate with one
another, and the boundaries of self and other as dictated by their
own constraints and drives.

Tsabar's exploration of intimacy continues in her *Work on Felt* series (2012–
ongoing)—flat floor and wall-hung pieces made of felt (underlain
by carbon fiber for rigidity) pierced by a piano string that pulls
a curve in the surface. The taut string can be plucked, creatin a
unique, reverberating sound that emanates throughout the space,
thanks to its connection to a guitar amplifier. Tightening or
loosening the string changes the degree of the felt surface's bow
and, thus, of the sound it makes.

At rest, Tsabar's sculptures always hold performative potential. However,
she often composes musical scores to be performed by collaborators
on the felt sculptures, either on their own or in constellation with
other sound sculptures or installations. What at first glance might
seem like takes on minimalist[4] painting inspired by the likes of
Ellsworth Kelly or Robert Morris, these works cross the boundar-
ies of painting (in an expanded sense), sculpture, sound, and
performance. By strumming, plucking, stroking, pushing, banging,
and otherwise producing sound, visitors and performers alike take
part in a choreography of sorts as they engage with the works and
the space containing them.

By extension, in Tsabar's large-scale installations, the work blurs the physic
limits of its material, becoming both embedded in and complici
with the architecture that surrounds it.[5] Along with speakers,
cables, and sometimes other elements, the architecture becomes
sculptural, visual, and sonic at once. It has as much impact on
sound as its origin point, be it produced by guitar strings or micro
phones embedded inside wall cavities—as in *Closer* (2014) or th
Propagation series (2012–ongoing)—or broken guitars scattered
across the floor and restrung into formations—as in the *Melody
of Certain Damage* series (2018–ongoing).

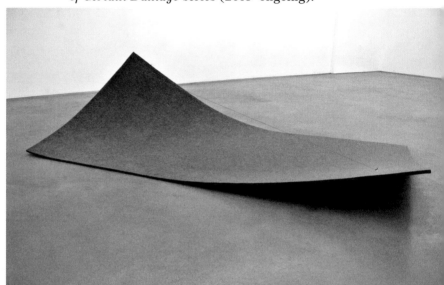

Work on Felt (Variation 1),
2012. Felt, carbon fiber,
epoxy, wood, archival PVA,
bass guitar tuner, piano
string, piezo microphone,
guitar amplifier, 152×269×82
cm. Photo: Anna Patin.
Courtesy: Dvir Gallery,
Tel Aviv / Brussels

The installation *Propagation (Opus 2)* (2013) comprises freestanding walls
and hanging columns, each embedded with a different piece of
audio and lighting equipment (e.g., guitar amplifier, stage light,
stage monitor, etc.). Each of the walls and columns can be consid
ered a stand-alone sculpture with the potential to emanate soun
or light from within, but also part of a larger installation that
creates its own unique soundscape. *Propagation (Opus 3)* (2015)
takes form on one large gallery wall: a wall is built in front of
an existing gallery wall with the space in between acting as a
sound box, resonating from the strings that are pulled across th
lower part of the wall. The sound of the plucked strings is ampl
fied back into the wall cavity itself, creating sound coming
from within and around the walls at once. The lines and visual
elements on the wall are cables and sound devices. In this sense
the piece is a visual system that represents itself rather than
another entity or experience.

Similar to the *Propagation* series in its use of wall cavities as sound boxes,
though more intimate in nature, *Closer* simply comprises two
standing walls that meet to form a corner. Upon approach, view
ers see a microphone embedded into each wall, but after turning
the corner, one sees—and can play—cavities carved into the
walls. Reaching through one cavity, the viewer discovers strings
embedded within the wall, while the other cavity acts as an ech
chamber for the human voice. A viewer or performer facing the
corner can sing and play in this highly intimate, personal space
without being seen by others in the gallery. The cavities are

cherry red—referencing the classic finish of electric guitars, as well as human innards—and the sensation of reaching into the walls can seem as intimate as permeating another human body. This tension speaks to the intimacy generated in Tsabar's afore-mentioned sculptural works, but here, it carries more direct notions of infiltrating a space, occupying it.

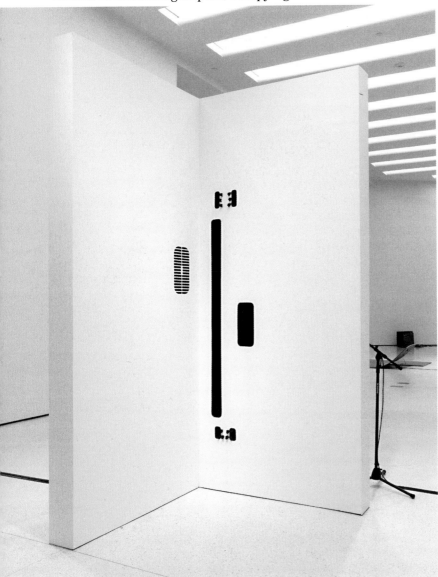

Closer, 2014. Wood, metal, microphones, microphone stands, tuning machines, guitar strings, microphone cables, PA system, 138×138×23 cm. Exhibited as part of the performance series *Blood Makes Noise* at Solomon R. Guggenheim Museum, New York, 2014. Photo: Kristopher McKay. Courtesy: Solomon R. Guggenheim Museum, New York

In fact, the act of piercing the wall is quite explicitly explored in Tsabar's photographic series *Untitled* (2012–ongoing), which features the artist and her partner piercing a white wall[6] with various body parts through holes that seem tailored to their anatomy. This series speaks directly to female empowerment and the ability to inhabit a void that Tsabar usurps. The freedom to enter what might loosely be considered a "glory hole," has been inherited by men through a long history of patriarchy.[7] Tsabar seizes the power to dominate the wall cavity, a space she returns to again and again in her works. The cavity here represents, perhaps, "real-ness"—it's where sound isn't muffled, where the unseen truth lies.

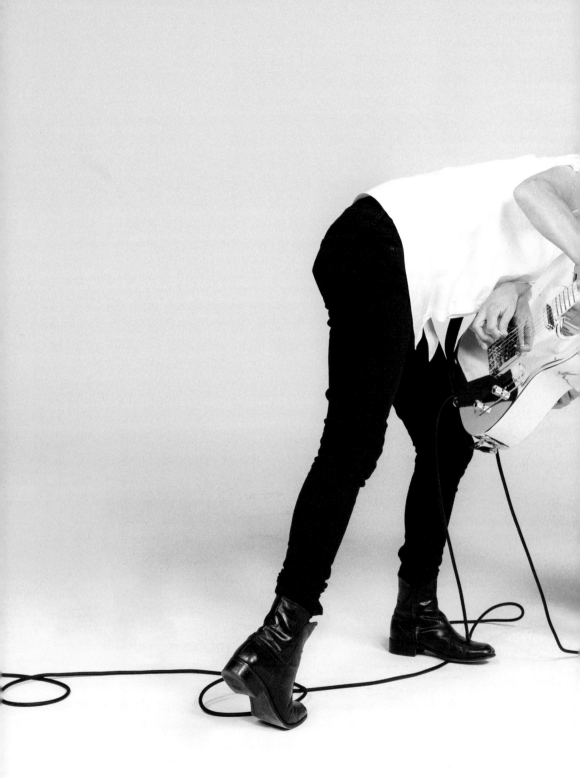

Untitled #3 (from the *Double Face Museum Series*), 2016. Dye sublimation print, polished aluminium frame, 104×129.5 cm. Photo: Kris Grave
Courtesy: the artist

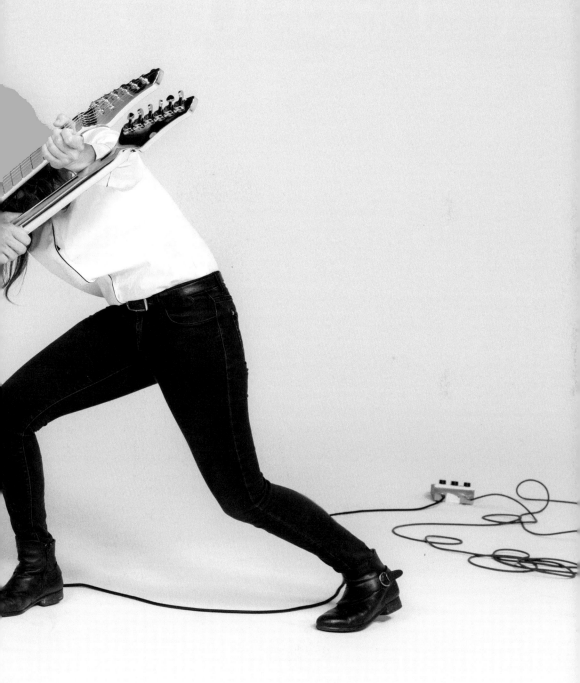

Upending the notion of penetration (of a space or an object), presenting multiple points and ways with which to engage each artwork, and granting viewers "democratic" freedom, all speak to a multiplicit that is at the basis of feminist thinking.[8] Emblematic of Tsabar feminist sensibility are *Melodies of Certain Damage* (2018), *Melodies of Certain Damage (Opus 2)* (2018), and *Melodies of Certain Damage (Opus 3)* (2019), in which the pieces of shattere guitars, sprawled on the floor, are restrung to create a collectiv of sculptures. Reconfiguring the musical "debris"[9] in an unconventional way creates a constellation of resynthesized instruments a phoenix rising from the wreckage. Tsabar's transformation of remains from the iconic action of breaking a guitar, to create a new functioning order, in many ways undermines the historic gendered manifestation in rock 'n' roll. In fact, the first recorde broken guitar dates to 1964 by Pete Townshend from the band The Who. Townshend was a student of Gustav Metzger (who als did visual projections for some of The Who's early shows), and h guitar-breaking was influenced by Metzger's *Auto-Destructive Art*,[10] a movement that critiques human destructive capabilities through wars and violence. The image of the male rock star, able freely to express anger and rebellion, and to impose violenc has become almost cliché today.[11] By maintaining the compositic of the guitars as they originally fractured, Tsabar focuses on the aftermath of the violence, the debris. Transforming the remains— the "victims" of violence—into a new and beautiful landscape is an empowering female act. For this reason, Tsabar chose to collaborate with and empower musicians who identify as femal as she often does in her performances.

Tsabar's myriad explorations of sound as sculptural material—as well as of architecture and human participants as mediums through which sound is created—are ultimately investigations of power and vulnerability. The unique configurations Tsabar imposes on view ers, spaces, and sculptures generate an intimacy that ultimately sensitizes us to the spaces we inhabit—and how we choose to inhabit them. Having the power to parse a space and to inhabit a void, to occupy something beyond ourselves by simply creating sound, can be both empowering and destabilizing, but at its best it leads to a small awakening through the mere engagement with Tsabar's work.

1. Naama Tsabar, "Without", *Art Haps*, August 09, 2014: https://static1.squarespace.com/static/533d8a50e4b0d9f7ba7 eec27/t/5beaff11758d46542b47fafc/15421 27381709/NT-WITHOUT-ARTHAPS.pdf

2. Simone de Beauvoir, *The Second Sex*, trans. Constance Borde and Sheila Malovany-Chevallier (New York: Vintage Books, 2011), 330.

3. Judith Butler, *Gender Trouble: Feminism and the Subversion of Identity* (New York and London: Routledge, 1999), 23.

4. In recent years, revisionist art history trends have expanded how art movements such as Minimalism are thought of and presented in an effort to broaden them beyond mostly male and Western phenome na. Much work is being done in the field t include female and non-Western perspectives and present them on par with other contemporary developments. One notable example is the exhibition *Other Primary Structures*, presented at the Jewish Museu in New York in 2014 and curated by Jens Hoffmann. Conceived as an homage to the iconic 1966 exhibition *Primary Structures Younger American and British Sculptors*, c rated by Kynaston McShine also at the Je ish Museum, *Other Primary Structures* aimed at widening the spectrum of minim art through the inclusion of artists who were working, at the same time,

in other regions, such as the Middle East, Central Europe, and South America. Another notable example is the recent policy change of the Dia Art Foundation, which, since the appointment of its new director Jessica Morgan in 2015, has started a campaign to include more female artists in its collection and program.

5. "In Foucault's concept of statement, investigative practices or transformational activities and their constructed objects are linked together. This defines Foucault's importance for the analysis of architecture. He enables us to treat as statements and as part of a discourse entities that are neither spoken nor written. Constructed objects can be considered as components of a discursive formation. The practices of the construction, inclusion, and exclusion of objects can be related to the rules and patterns of such formations." Paul Hirst, "Foucault and Architecture," *AA Files*, no. 26 (Autumn 1993), 53. Responding to architecture inherently means responding to the structures of power that architecture represents. Architecture is the manifestation of political power, a model for a system of thought and hierarchy that shapes a given society. One need not look further than historical monumental structures, but this is visible in today's architecture as well. For a thorough discussion of power and architecture, see Michel Foucault's *Discipline and Punish: The Birth of the Prison*, trans. Alan Sheridan (New York: Pantheon Books, 1977).

6. The action of "piercing the wall" can also be seen as a clear response to the most logical and historically rooted association: the act of "building a wall." Furthermore, if architecture is a manifestation of power, then, by extension, one can consider the wall masculine. Walls can be thought of as permanent, aggressive, intrusive; they divide and delineate space and control movement. In Israel, where Tsabar grew up, the wall can be seen as a reference to the politically charged separation fence or barrier that divides Israel and Palestine (and, of course, other such structures, like the Berlin Wall) but also to Jerusalem's Western Wall. Her work *Propagation (Opus 2)* (2013), which was presented at the Tel Aviv Museum of Art, comprised freestanding walls fitted with various musical equipment. Like a room dismantled into individual components, the walls faced different directions, supported by objects such as amplifiers, loudspeakers, and monitors, as well as dollies, beer boxes, and so forth.

7. A "glory hole" is a hole in a wall or partition, usually found in public lavatory stalls or adult video arcade booths and sex lounges, through which a penis can be inserted, or for people to otherwise engage in sexual activity or observe a person in an adjacent space while one or both parties maintain anonymity.

8. In Luce Irigaray's seminal text on female anatomy and multiplicity, *This Sex Which Is Not One* (1985), she upends male-centered structures of language and thought and challenges Western culture's enduring phallocentrism. She writes:

"Within this logic, the predominance of the visual, and of the discrimination and individualization of form, is particularly foreign to female eroticism. Woman takes pleasure more from touching than from looking, and her entry into a dominant scopic economy signifies, again, her consignment to passivity: she is to be the beautiful object of contemplation. While her body finds itself thus eroticized, and called to a double movement of exhibition and of chaste retreat in order to stimulate the drives of the 'subject,' her sexual organ represents the *horror of nothing to see*. A defect in this systematics of representation and desire. A 'hole' in its scoptophilic lens. It is already evident in Greek statuary that this nothing-to-see has to be excluded, rejected, from such a scene of representation. Woman's genitals are simply absent, masked, sewn back up inside their 'crack.'" See Irigaray, "This Sex Which Is Not One" in Irigaray, *This Sex Which Is Not One*, trans. Catherine Porter, with Carolyn Burke (Ithaca, NY: Cornell University Press, 1985), 25–26.

9. In this context, the metaphorical use of the word *debris* has a specific connotation. In an unpublished video presentation of the process behind the *Melody of Certain Damage* series, Tsabar has referred to, among other moments in history, the recent destruction of Palmyra by the Islamic State of Iraq and Syria (ISIS). For an interesting discussion on the history of the destruction of architecture, especially historical monuments, from ancient times through the totalitarian regimes of the twentieth century and today's ISIS in the Middle East, see "The Destruction of Cultural Heritage: From Napoléon to ISIS," an anthology compiled by Pamela Karimi and Nasser Rabbat, available on the *Aggregate* website: http://we-aggregate.org/project/the-destruction-of-cultural-heritage-from-napoleon-to-isis.

10. The term Auto-Destructive Art was first coined in Gustav Metzger's article "Machine, Auto-creative, and Auto-destructive Art" in the 1962 issue of the journal *Ark*. In 1959, at the height of the Cold War, Metzger began a series of acid paintings that he considered protests against nuclear warfare. He sprayed acid onto sheets of nylon, producing various-shaped holes as the acid ate the plastic. He explained, "The important thing about burning a hole in that sheet [...] was that it opened up a new view across the Thames of St. Paul's Cathedral. Auto-Destructive Art was never merely destructive. Destroy a canvas and you create shapes." See Stuart Jeffries, "Gustav Metzger: 'Destroy, and you create,'" *The Guardian*, November 26, 2012, https://www.theguardian.com/artanddesign/2012/nov/26gustav-metzger-null-object-robot.

11. The guitar smash was first explored in Tsabar's seminal early work *Untitled (Babies)* (2008), a live performance documented in video during which Tsabar plays guitar and sings a rock song. As the performance evolves, she begins to smash her guitar against the stage. However, unlike the traditional guitar smash, the stage, not the guitar, breaks.

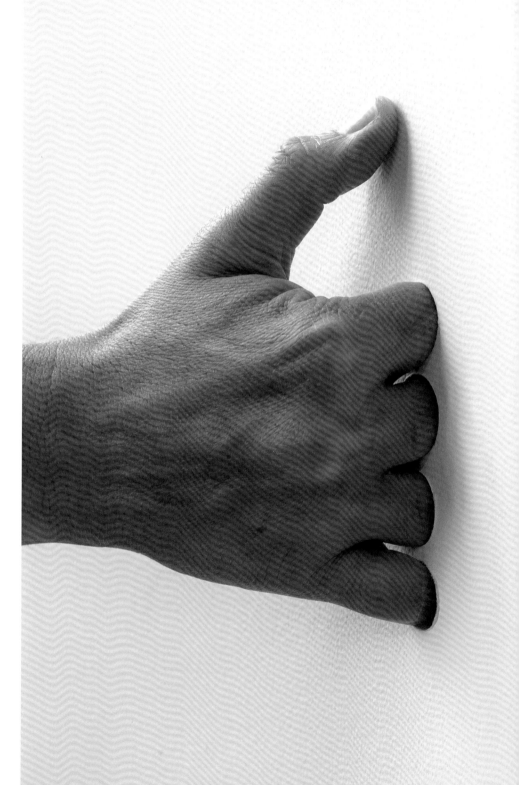

Untitled, 2018. Inkjet print on Photo Rag paper, 68×96 cm. Photo: Naama Tsabar. Courtesy: the artist; CCA – Center for Contemporary Ar
Tel Aviv; Dvir Gallery, Tel Aviv / Brussels

Untitled, 2018. Inkjet print on Photo Rag paper, 68×96 cm. Photo: Naama Tsabar. Courtesy: the artist; CCA – Center for Contemporary Ar
Tel Aviv; Dvir Gallery, Tel Aviv / Brussels

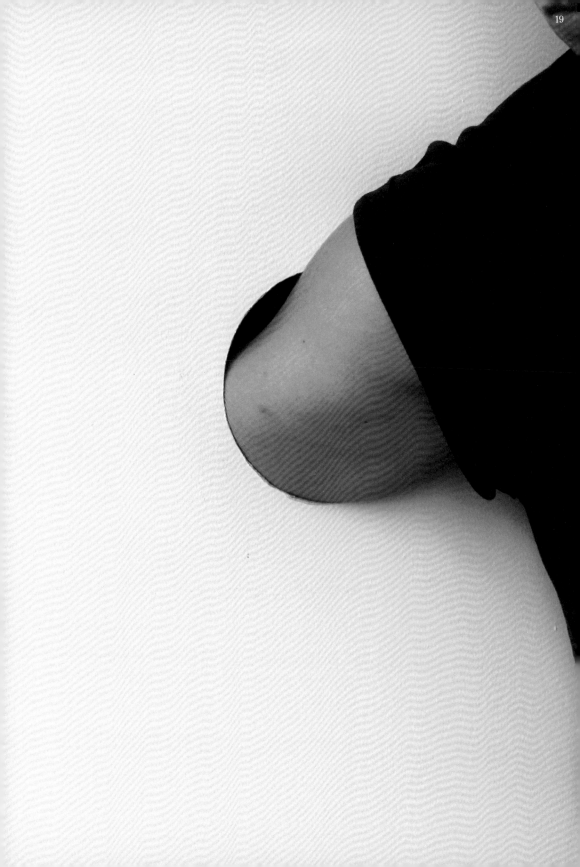

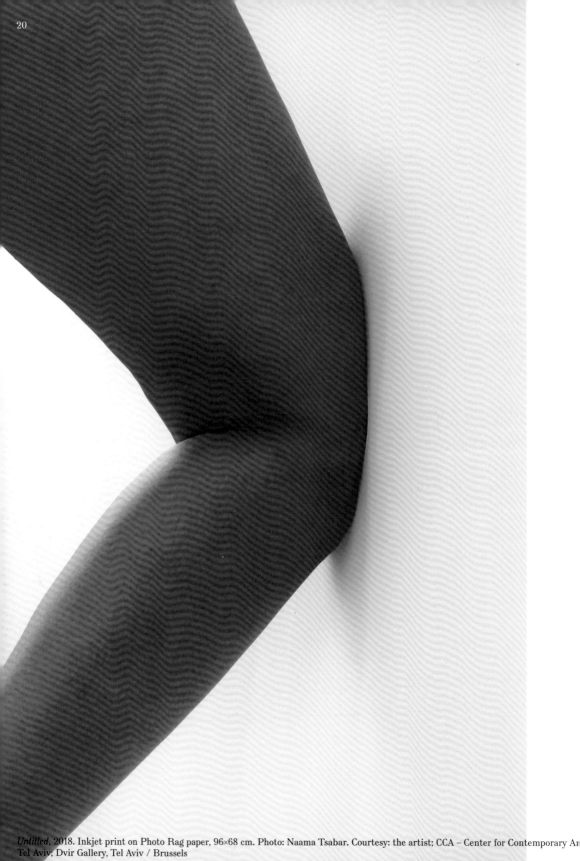

Untitled, 2018. Inkjet print on Photo Rag paper, 96×68 cm. Photo: Naama Tsabar. Courtesy: the artist; CCA – Center for Contemporary Ar
Tel Aviv; Dvir Gallery, Tel Aviv / Brussels

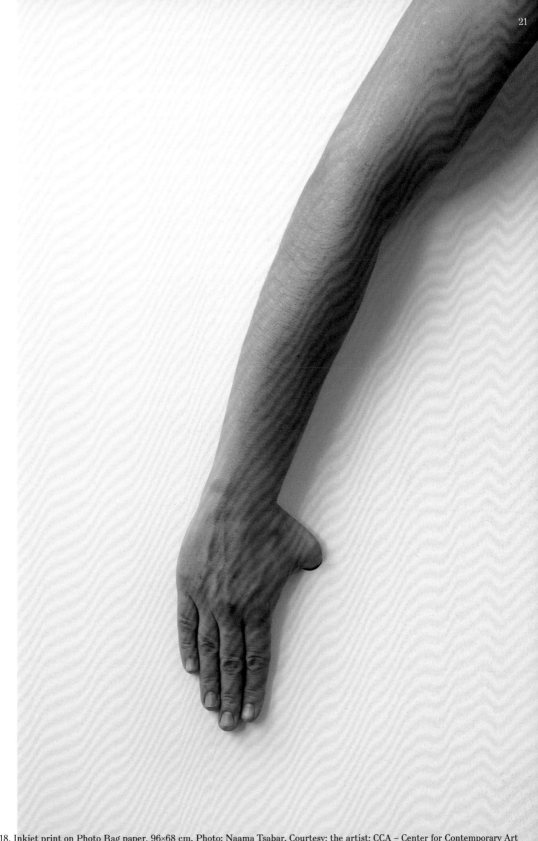

itled, 2018. Inkjet print on Photo Rag paper, 96×68 cm. Photo: Naama Tsabar. Courtesy: the artist; CCA – Center for Contemporary Art
Aviv; Dvir Gallery, Tel Aviv / Brussels

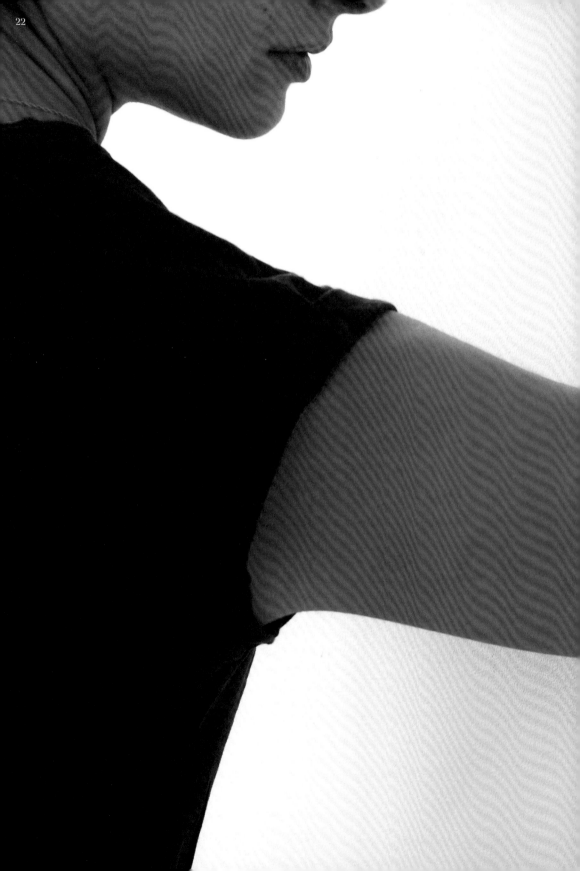

ntitled, 2018. Inkjet print on Photo Rag paper, 68×96 cm. Photo: Naama Tsabar. Courtesy: the artist; CCA – Center for Contemporary Art
l Aviv; Dvir Gallery, Tel Aviv / Brussels

THE TRANSITION TO REAL TIME

Ines Goldbach

blow strikes the two-meter-tall hanging felt, which thuds and swings. A hand strokes the raw surfaces—dark blue, then claret or even black—hanging on the walls of the exhibition space. Another blow. Now an arm rubs the felt, creating other sounds. Afterward, it will be the whole body, a knee, a hip, the back. Each time a tone, a sound. Dark, full, and flooding the space. Naama Tsabar's work is more than the objects within a space. It's also all that lies in between: everything stable and permanent and everything fleeting and temporary, like a song that rises up and then disappears. Describing the work or communicating it through photographs is a challenging endeavor, for how can all this, coming at you all at once, be grasped?

Transition #4, 2018. Exhibition view at Kunsthaus Baselland, Muttenz / Basel. Photo: Serge Hasenböhler

ome pieces are works on felt with resonant strings in different forms, shapes, and colors, linked up to the kind of amplifiers we know as accessories to electrical guitars or fundamental elements of rock concerts. Further on are speakers akin to concrete-constructivist works yet that reveal their own amplifying character from the slight droning and the graphic arrangement of cables, buttons, and levers. Microphones are united in a sculptural formation, like a pack; their cables resemble a drawing scrawled across the ground, writing itself onto the architecture. Everything is connected, and it seems to be waiting and ready for whoever will activate it—and for whoever walks from room to room attempting to grasp everything that rings, swings, and sounds.

here were six performers for the exhibition *Transitions #4* presented in 2018 at the Kunsthaus Baselland, performers who sometimes plucked the taut strings of the painting-like sound objects, played them with a bow, or touched them with their whole bodies to generate sound. And across it all was a song that first filled the spaces like one long, drawn-out sound, the source of which was hard to pinpoint in the space. Surrounded by microphones—almost encased in them—the singer turned and twisted; only fragments of her lyrics were comprehensible. And yet it became evident that this song inscribes itself so deeply in the spatial structure and those present that everything becomes a resonance chamber.

Tsabar's works cannot be experienced at arm's length. Neither the people who activate them nor those who participate as audiences remain unmoved. The sounds shift into tones, rhythms, and ultimately, music. They penetrate the immediate surroundings and transform them into a massive sound body, overcoming the (architectural) limits of the space to encompass everything and everyone within

Work On Felt (Variation 15), Dark Blue, 2017. Felt, carbon fiber, epoxy, wood, archival PVA, bass guitar tuner, piano string, piezo microphone, guitar amplifier, 185×145×70 cm. Photo: Christopher Stach. Courtesy: Kasmin, New York

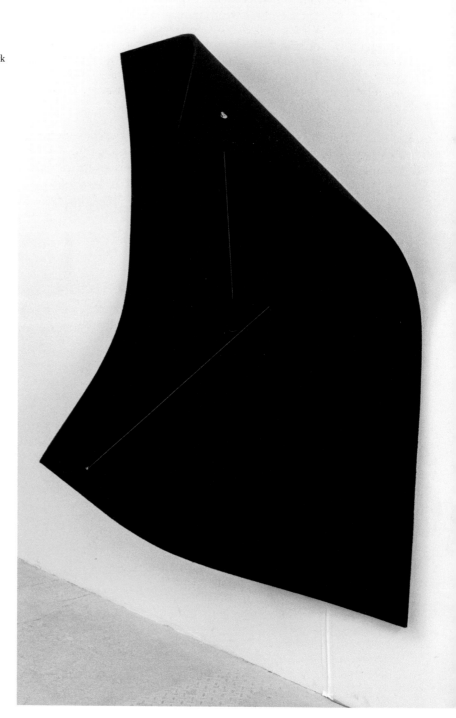

abar's work offers reinterpretations of the familiar, usual, and normal, it makes new meanings. That which is functional and technical—indeed, all that has till now generally been ascribed to a masculine domain through contemporary music, electric guitars, loudspeakers, and amplifiers—becomes novel, poetic, sensorial, and rich in meaning in the artist-musician's cosmos. Further, the female-identified performers represent a transition, a switch, a change. Sexuality, violence, power, love, feminism, gender roles, war, displacement, identity—Tsabar places these issues, which should be front of mind for us today more than ever, at the center of her work. What role does the body play as the bearer of social and political meaning? How much respect does our society accord women? And how much to those who are gay, queer, dark-skinned, have migrant backgrounds, or who slip through the cracks in society? How open is art to questions about unhindered, free, and democratic access to art that doesn't favor the rational over the immediate?

sabar's work creates an offering. It enables a fusion of genres that are usually dealt with in isolation—painting, drawing, sculpture, installation, performance, and music—to make a unified whole, and in doing so, it offers her viewers an opportunity for holistic thinking.

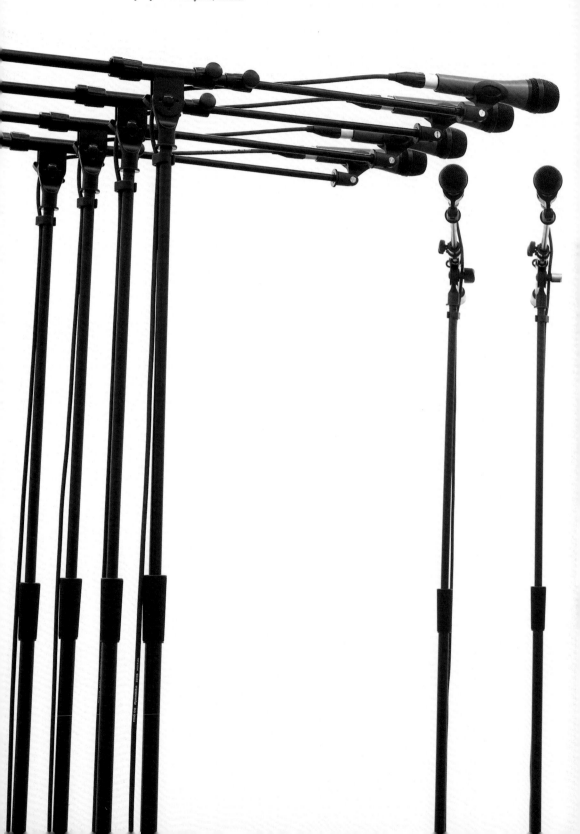

Barricade #3 (detail), 2016. Twelve microphones and microphone stands, matching audio equipment, cables, gaffer tape, 157×249×249 cm
Photo: Diana Larrea. Courtesy: Spinello Projects, Miami

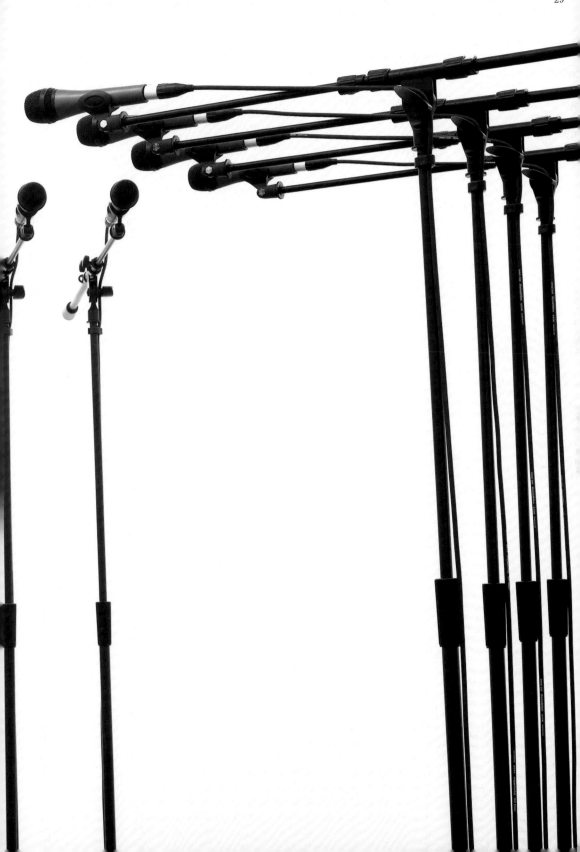

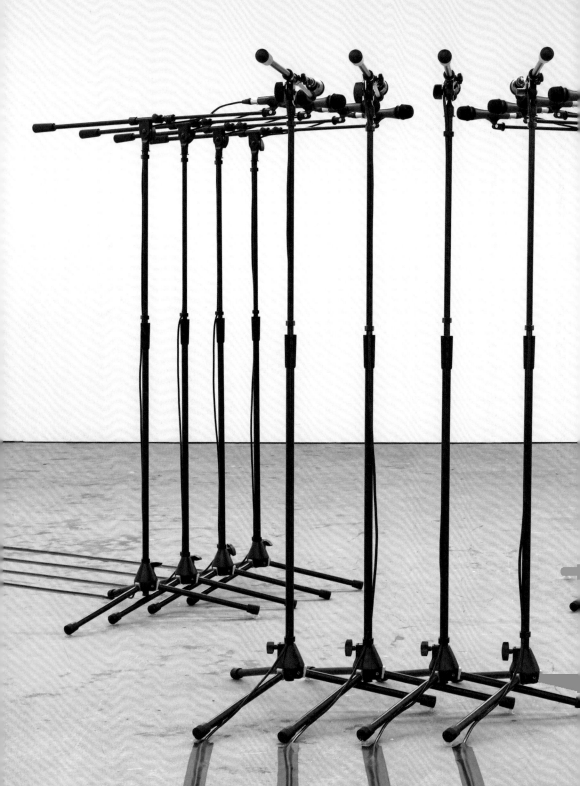

Barricade #3, 2016. Twelve microphones and microphone stands, matching audio equipment, cables, gaffer tape. Installation view at Kunsthaus Baselland, Muttenz / Basel, 2018. Photo: Serge Hasenböhler. Courtesy: Dvir Gallery, Tel Aviv / Brussels

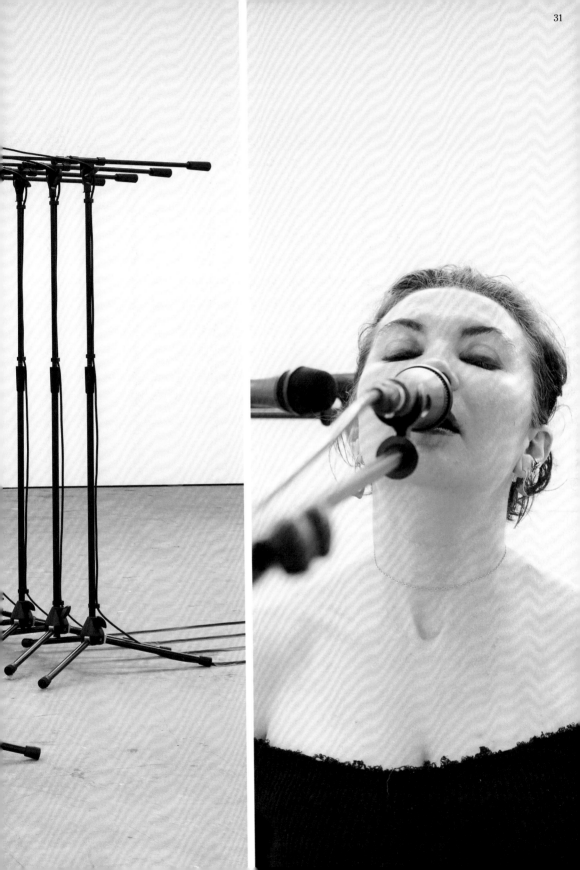

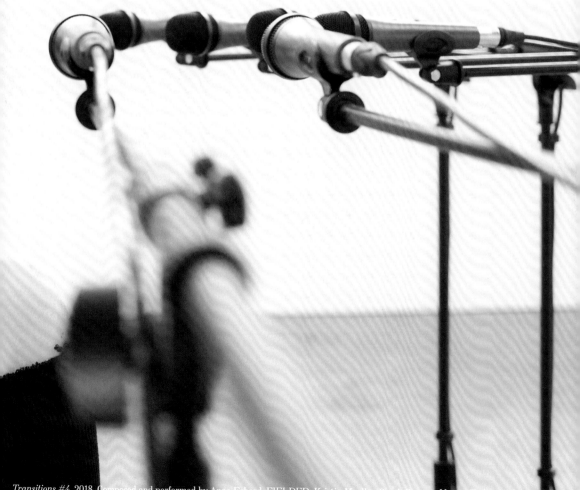

Transitions #4, 2018. Composed and performed by Anna Erhard, FIELDED, Kristin Mueller, Sarah Strauss, Naama Tsabar, and Anja Waldkirch.
Performance view at Kunsthaus Baselland, Muttenz / Basel. Photo: Carmen Wong Fisch. Courtesy: Kunsthaus Baselland, Muttenz / Basel.

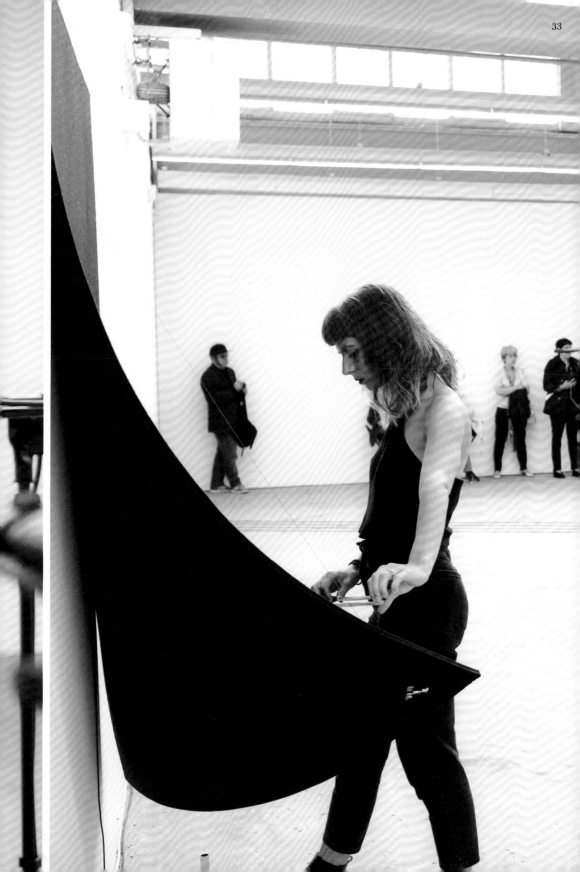

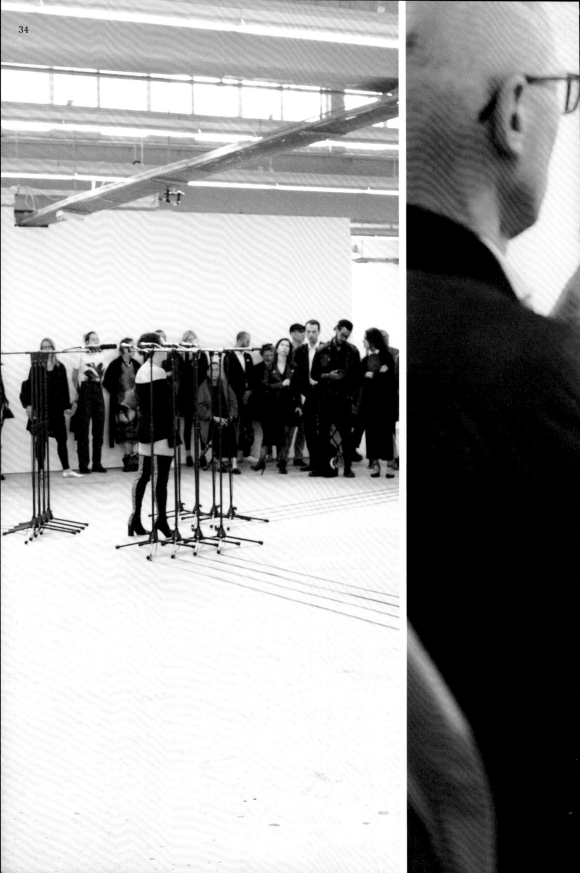

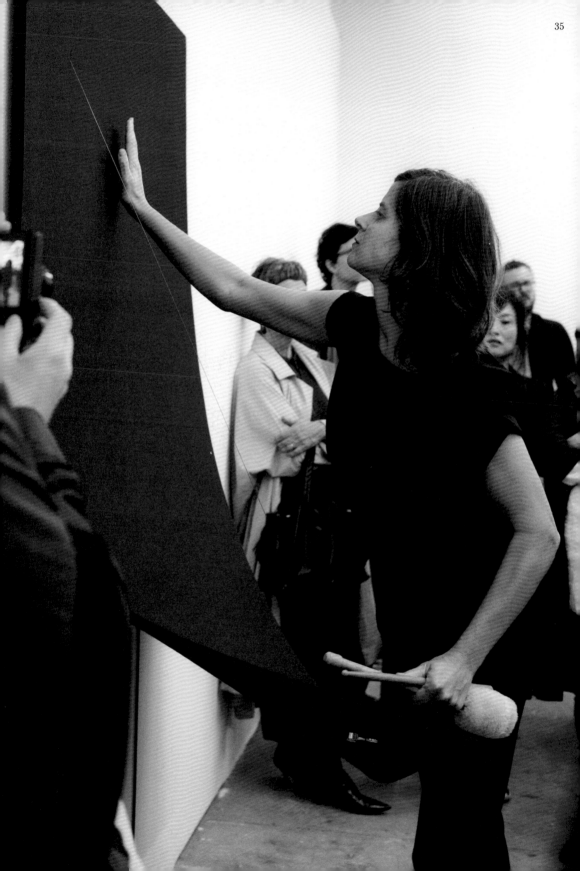

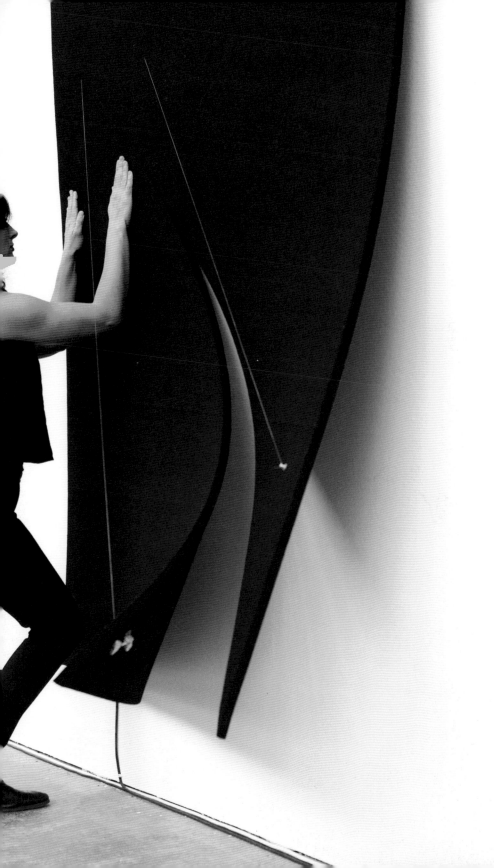

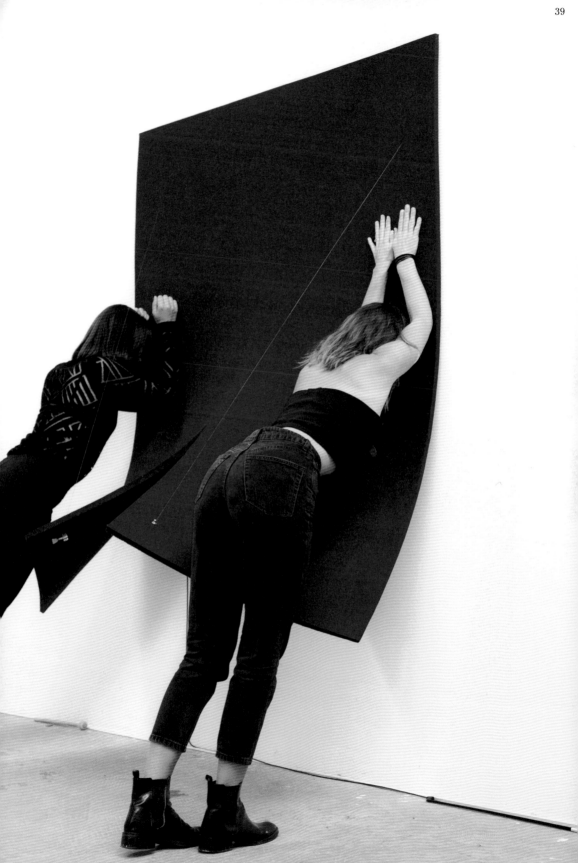

LIKE A STREAM, A NATURAL RIVER OF SORTS

Naama Tsabar in Conversation with Ines Goldbach

es Goldbach As a starting point, I would like to focus
a recent series of work, *Transition*, that you showed in Basel.
t first sight, the pieces look similar to paintings and, sometimes,
om a certain distance, like drawings; but on the other hand,
ey act like speakers or even, in combination with the space and
chitecture of the Kunsthaus Baselland, like huge instruments
emselves. What is the difference for you when you install them
d see them at rest—silent—or, in comparison, activated and
nctioning as speakers, filling the space with sound?

aama Tsabar For each canvas work included in the *Transition* series
(2015–ongoing), I took apart an amplifier or powered stage moni-
tor. I took out all the internal and external components—the
speaker, knobs, wires, circuit board, etc. I extended the existing
wires that run in the circuit board using the same color and gauge
of wire. I used the wires and knobs like a painter's palette and
made visual compositions on the canvas. All the wires puncture
the canvas and connect back to the circuit board and speaker
behind the canvas; that way, the amplifier gains a new formal
and visual existence while still retaining its prior functionality.
It's a sculptural painting that has the ability to output sound.
The sculptures from the *Works on Felt* series (2012–ongoing) actu-
ally double as instruments, when the string that sculpts them is
plucked. I'm interested in these in-between states of existence,
when an object can change its reading and field of action by its
activation. I feel this expands what the object is; it brings them
into a more complex sensual existence, one that is much more in
tune with the way we experience life. I don't like authority, to be
framed—restricted. These works break the borders that were set
for them. They do this by possessing the potential to expand into
a different field of action; they are in a constant state of transition.

.G. Recalling former works like *Propagation (Opus 3)*
2015–17) or *Untitled (Speaker Walls)* (2010), one has the impres-
ion that there is a development and process within the series of
vorks. Is that true, that one work leads towards the next and
onstructs an image of a whole orchestra *en masse*? I think there
s also development in terms of how the viewer is led through
he space, as works like *Propagation (Opus 3)* still play with the
dea of a *vis-à-vis* between the viewer and the artwork, although
he viewer becomes a participant as they interact in some way
vith the encircling sound.

.T. *Propagation (Opus 3)* and *Untitled (Speaker Walls)* are linked, as
they both deal with the construction of walls and their transfor-
mation into sound-emitting architecture. As with the *Transition*
canvases, I was interested in the transparency of the system
within these works—a system where the functional and visual are
one; it's a system that visually represents itself. *Untitled (Speaker
Walls)* predates *Propagation (Opus 3)* by five years. In a way, it
goes the extra step and gets rid of the encasing object (the speaker
box) completely; sound is transformed by the architecture of the
space itself. There is a movement between these works from the
domestic to the public sphere—from constructing a wall out of
speaker boxes stacked on top of each other to transforming the

actual architecture of the museum walls. I think it's a personal expansion of my freedom of movement as an artist, but also a need to get the body closer to the wall, to instigate more extreme change in the structure itself through activation. Walls, and their marriage with sound, are a recurring theme in my works; sound transmitted through material, going beyond the physical borders of a space or a wall. In a way, marrying the two undermines the wall as a barrier. The wall becomes an element with which you can communicate outward and inward. It subverts the political use of a wall by thinking of its structure as a means to communicate rather than cut off.

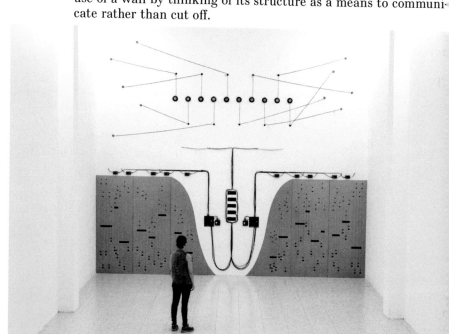

Propagation (Opus 3), 2015. Wood, speakers, amplifiers, mixers, wires, cables, piano strings, bone, cable holders, contact microphones, brass, sheet rock, 650×679 cm. Photo: Rodrigo Dada. Courtesy: MARTE – Contemporary, San Salvador

I.G. That brings me to another question: On one hand, you open your works to the public so viewers—nearly anybody who enters the space—are invited to activate your works. On the other, when we are talking about your musical performances, only women activate the works and occupy the space with their bodies and the sound from the works. Why do you make this distinction?

N.T. On a sensual level, I am interested in all viewers having an intimate physical experience with the work, if they choose to cross the border between their bodies and the objects. When we perform the work, there are rehearsals, learning how to play the pieces; this is a form of mastery, and with that in mind, I am very aware of the gender imbalance in the cultural sphere. I am interested in inserting the works into a newly gendered history, one that is not male-centric. I choose to work predominantly with women and gender nonbinary musicians and performers; a male musician needs to be really good and consciously evolved to meet our high standards in order to be considered as a performer.

I.G. With that in mind, let me go more into detail. If we talk about all the tools involved in creating an installation—speakers, amplifiers, piano strings, microphones, etc.—it sounds very technical. In the way you use them and activate them using

men's bodies, they become poetic, fluid, soft, and powerful.
wonder if this is a potential means of exploring certain meth-
s that belong in an idealistic way to people of all genders?

.T. Yes, it is a way to insert the works into a new history, to give
a stage and a voice to those who have been overlooked and
underestimated.

. In that sense, is the idea and title of *Transitions* also
link to the idea of reinterpreting and rewriting the history and
e understanding of women within music, within art, and with-
society generally? Hard-rock music, for example, still has
rongly male connotations.

.T. My feeling is that rewriting history is impossible, though it is
possible to expand that which has already been written, to look
at the pages of written history and see who was excluded and
why. Furthermore, it's important to make a conscious decision,
through our actions, to write a newly gendered history for gener-
ations to come. For me, the title *Transitions* is more about being
suspended in a transitional state, an elusive state between defini-
tions and borders, with freedom of movement between them.
Historically, the very definition of borders has been in the hands
of the white male. I am interested in creating platforms that ex-
pand the possibilities for movement and blur definitions. Doing so
is an important step toward seeing others who exist in between.

G. It is a challenge to find the right definition for your
ork—there is sound, music, the body, space, architecture, paint-
g, objects, performance, and gender. Is the application of so
any media a way to cross and somehow overcome the bound-
ries that were built up over the last decades of art history?

.T. I view my practice like a stream, a natural river of sorts—having
its own borders while passing through those defined and artifi-
cially established by man.

G. Considering the context in which the works might
e embedded, and looking at your *Works on Felt* series, there is
very strong visual connection to felt works by Robert Morris
om the 1960s and 1970s, although he very rarely, maybe never,
sed color felt, and of course there was no possibility of activat-
g them and playing them as instruments, nor was there ever
e possibility of touching them. How do you relate to this refer-
nce, and is it a means of extending and widening what contem-
orary sculptures or objects encompass?

.T. Yes, you're right: my first art-historical references for the felt
pieces were Joseph Beuys and Robert Morris—Beuys for the
performative qualities and the use of felt to deaden sound, and
Morris for his formal, gravity-sculpted felts. My *Works on Felt* are
a move away from both predecessors; by embedding carbon fiber
in the felt, the soft material gains the ability to maintain tension
and hold a form. It now looks like felt but acts like another
material. When the string is plucked, the felt–carbon fiber duo

becomes the sound chamber itself, and the tension of the string is that which sculpts and holds the form. In a way, these are form created by resistance to gravity. In addition, given the interactiv ty of the work, there is a question of the viewer's place—or rathe of the viewer who becomes the performer after activating the work. It constitutes both an intimate relationship between viewe and work and a public, stage-like relationship between one viewe and the next. And of course, there is the relationship between the art object and the sound wave, which also constitutes part of the sculpture—hence, the viewer plucking a string also exten the borders of the work, sending a wave of sound that diffuses through the exhibition space.

I.G. It sounds to me as if your work opens up not only a new understanding of how to *use* works of art but also, above all, how to generate a new relation to artworks that have, maybe within the last twenty years, become, in a broad sense, fetish objects. They are things to be admired, to be marketed and sold and installed on private and public walls. Are your works an attempt to create a space for the viewer, to include them in a very sensual way and to move them from being a viewer to becoming a participant?

N.T. I hope my works offer their audience a more intimate relationshi and experience. The works don't offer that relationship right away At first, they appear to follow the same rules of sight and display put in place by years of art history, and they can be installed on private and public walls. However, when they are activated and those borders are breached, they can also offer a more specific ar sensual experience and relationship between sculpture and body. For example, I recently learned that one of my felt works on dis- play in a private collection in a home is being played with regular by the collector's children—they are learning how to play with a big piece of felt! Another aspect of this is how the work also gair a visual history through these interactions and its use. When we perform on the works, we sometimes leave marks of action on th felt; this is an exciting moment for me, where the surface of the work responds to our actions, and a mark is left of a movement that has taken place and it is now an integral part of the work.

I.G. As you mention Joseph Beuys, I wonder if artworks and exhibitions that include the viewer, their movement and being present in the space, bring us to the point that art is more about (sensual) experience and how we navigate through spaces, not only in relation to architecture but also conceptually, regard- ing the crossing of (social) boundaries.

N.T. Yes, I believe so. In a way, I think it's also about a new under- standing of space and a flow established in the 21st century by online platforms and new means of communicating. I am trying to bring those ideas back into material form, back to our bodies.

I.G. Do you think that music, sound, movement through the space, and the possibility of touching the pieces and being surrounded by them helps us feel more present and aware of ourselves in the moment?

T. I think there is a special form of being present when one per-
 forms; for the performer, time passes differently and the senses
 are heightened. I think that has to do with being watched
 and the importance of an action. It's almost as if your own eyes
 roll back onto themselves, taking in movements, sounds, and
 actions in a heightened state of awareness. It's a commitment
 to our presence and our timed existence.

G. As we have been talking about a body of work that
 as and still is very important to your artistic handwriting,
 hich can be seen as a progression within your work, I wonder
 here it leads next. What will be your next step? What are
 u working on at the moment?

T. My practice is going in a few directions. I am working on a perfor-
 mative body of work with the female voice and the *Barricade*
 (2016–ongoing) installation series. I am very interested in the
 place of the female voice, specifically the melodic one, within our
 society and the potential it has to disrupt the patriarchy. I am
 also developing the role of architecture and the performative body
 within my practice through a series of wall inserts that explore
 the sculptural, reverberating space inside preexisting walls.
 Closely connected to my work *Closer* (2014), these installations
 shed light upon the structures and the hidden spaces that make up
 our environments. I'm thinking of the action of penetrating existing
 structures in order to rethink their internal order and function.

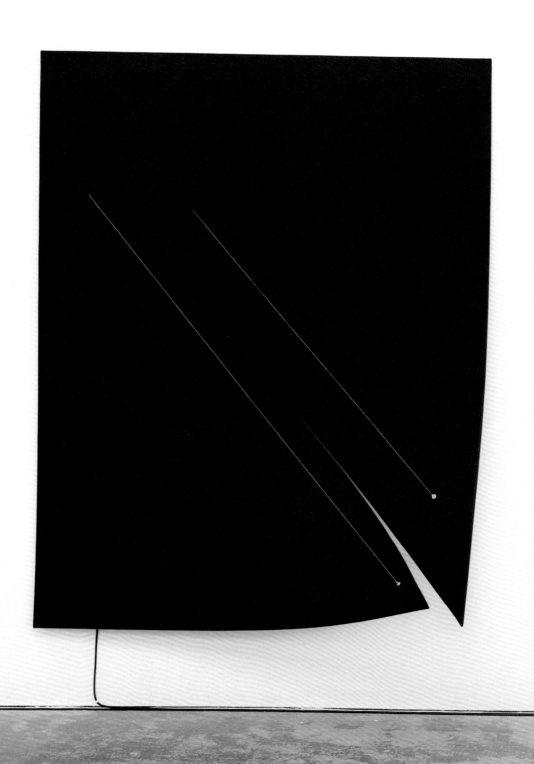

Work On Felt (Variation 11), Dark Blue, 2016. Carbon fiber, epoxy, wood, felt, microphone, guitar amplifier. Installation view at Kunsthaus Baselland, Muttenz / Basel, 2018. Photo: Serge Hasenböhler. Courtesy: Dvir Gallery, Tel Aviv / Brussels

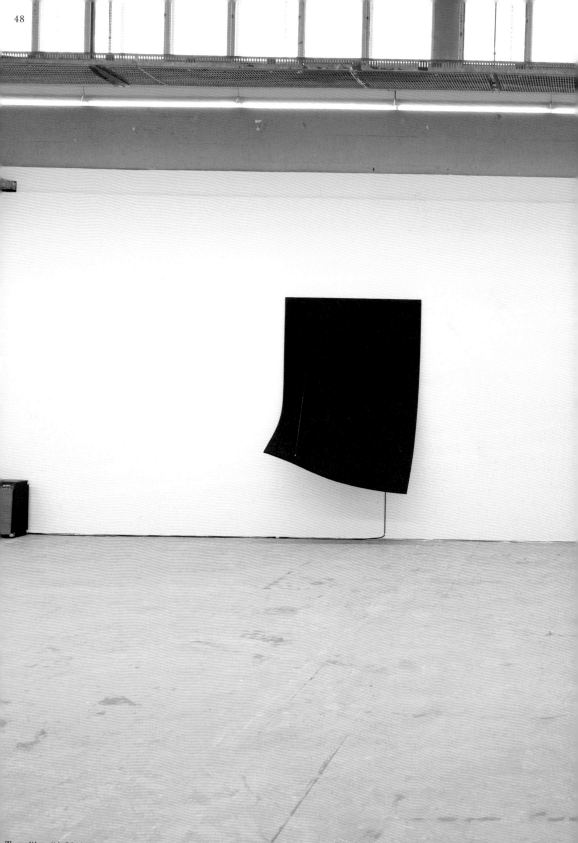

Transition #4, 2018. Exhibition view at Kunsthaus Baselland, Muttenz / Basel. Photo: Serge Hasenböhler

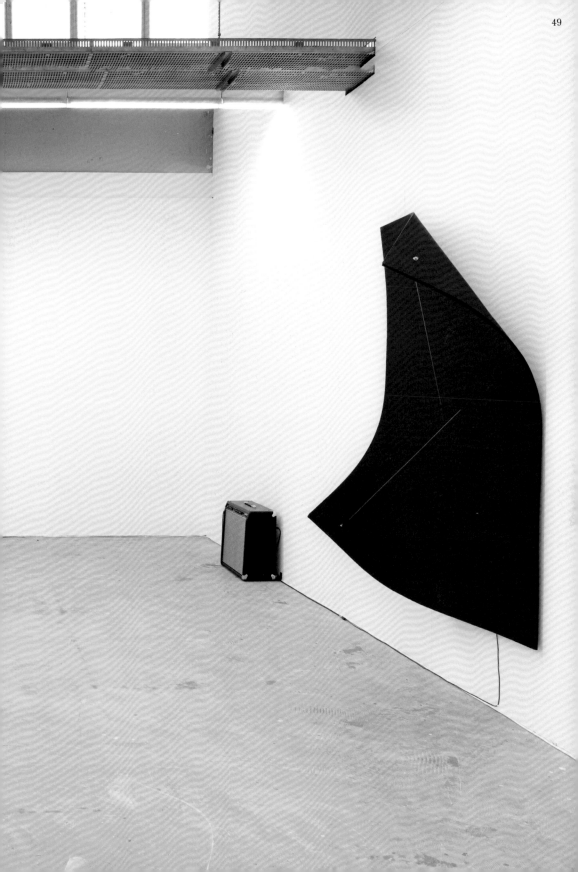

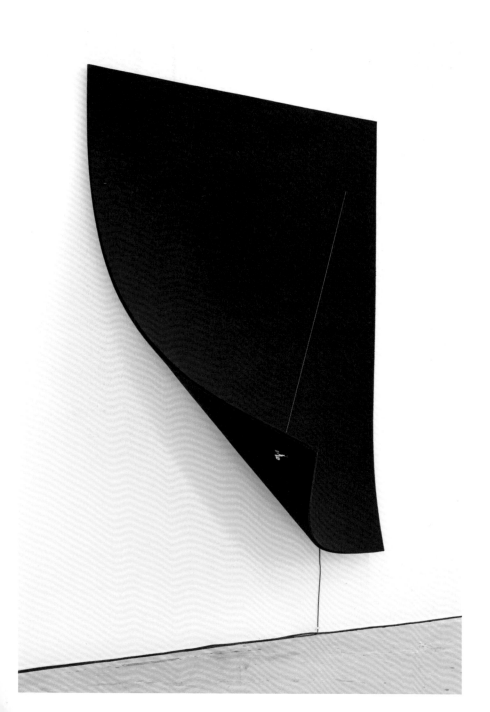

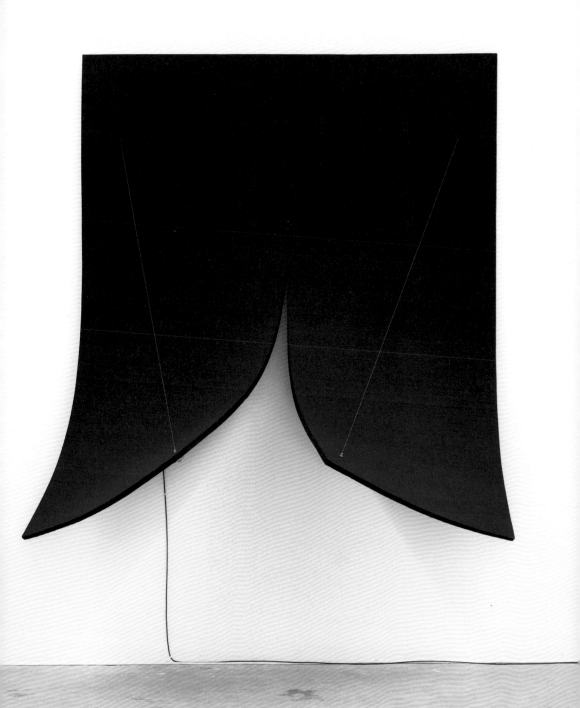

k On Felt (Variation 8) Bordeaux, 2016. Felt, carbon fiber, epoxy, wood, archival PVA, bass guitar tuner, piano string, piezo microphone, ar amplifier. Installation view at Kunsthaus Baselland, Muttenz / Basel, 2018. Photo: Serge Hasenböhler. Courtesy: Spinello Projects, Miami

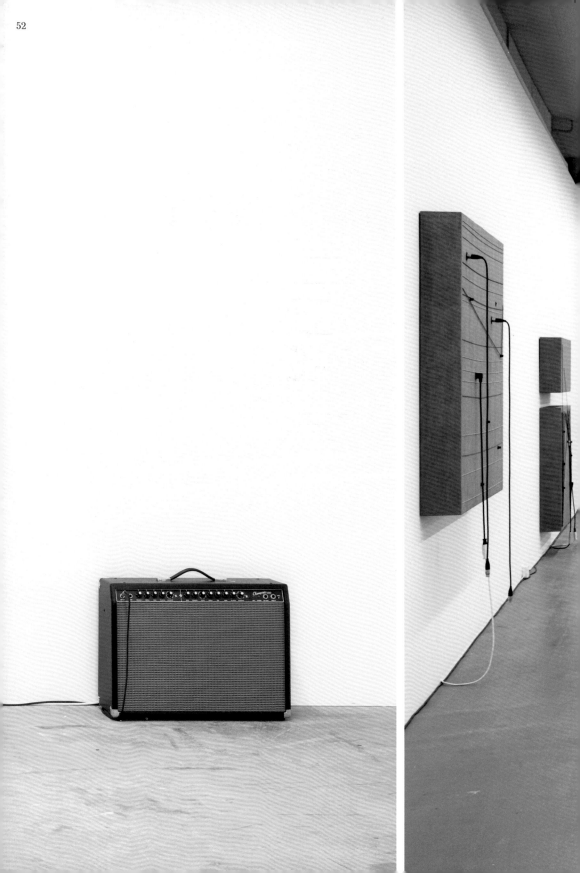

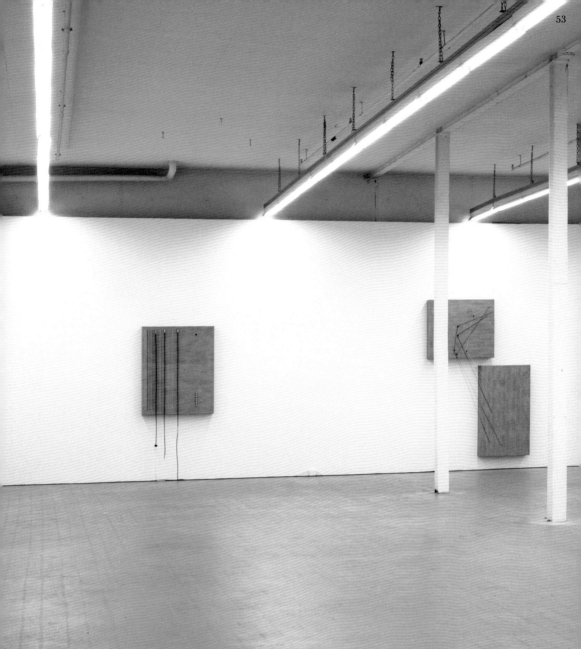

ansition #4, 2018. Exhibition view at Kunsthaus Baselland, Muttenz / Basel. Photo: Serge Hasenböhler

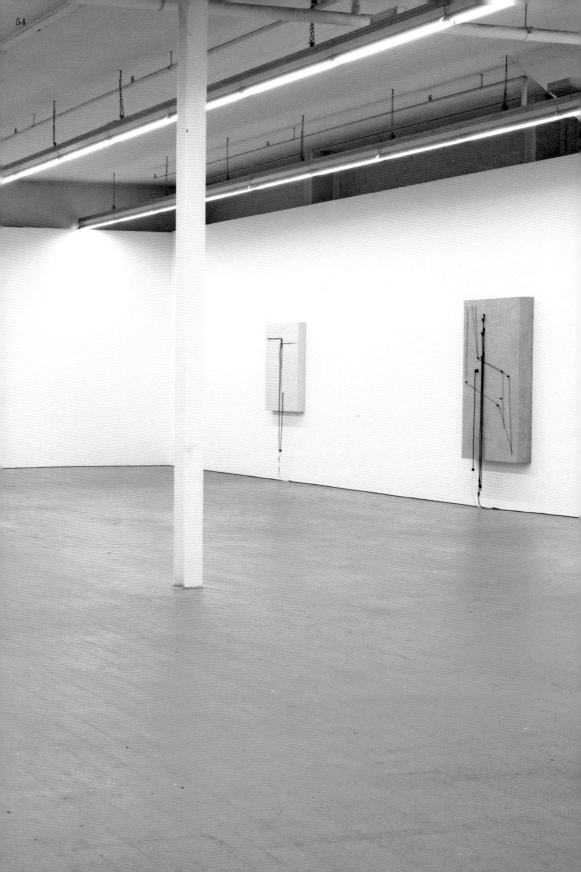

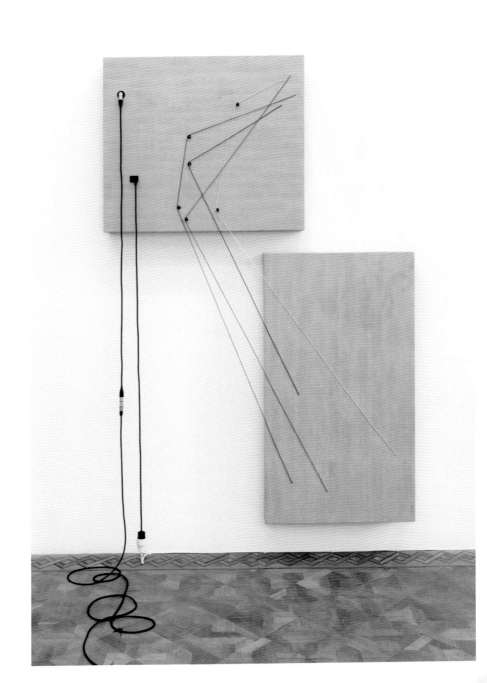

...ansition, 2016. Wood, canvas, cables, disassembled Behringer Eurolive F1220D powered speaker (knobs, wires, circuit board, ports, speaker). ...stallation view at Dvir Gallery, Brussels. Courtesy: Dvir Gallery, Tel Aviv / Brussels

Transition, 2016. Wood, canvas, cables, disassembled Galaxy Audio PA6BT Hot Spot powered speaker (knobs, wires, circuit board, port
speaker). Installation view at Dvir Gallery, Tel Aviv. Photo: Elad Sarig. Courtesy: Dvir Gallery, Tel Aviv / Brussels

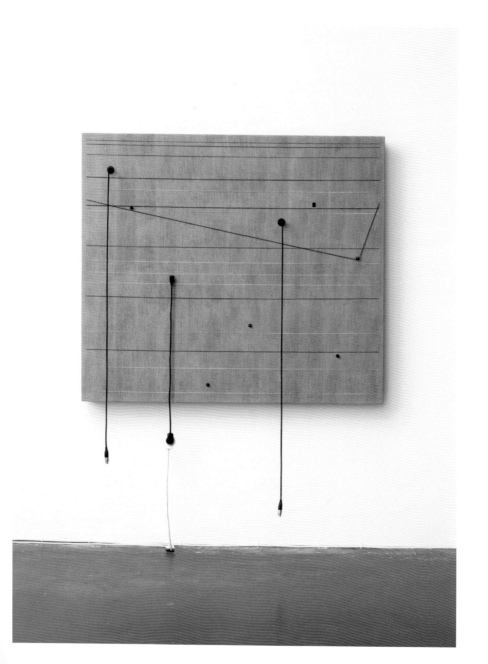

nsition, 2016. Wood, canvas, cables, disassembled Galaxy Audio PA6BT Hot Spot powered speaker (knobs, wires, circuit board, ports, ⎯aker). Installation view at Dvir Gallery, Tel Aviv. Photo: Elad Sarig. Courtesy: Dvir Gallery, Tel Aviv / Brussels

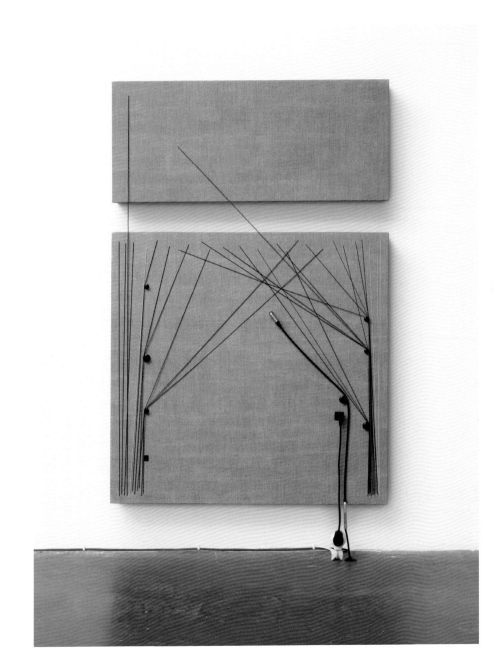

Transition, 2015. Wood, canvas, cables, disassembled Marshall MG10 guitar amplifier (knobs, wires, circuit board, ports, speaker). Installat
view at Kunsthaus Baselland, Muttenz / Basel, 2018. Photo: Serge Hasenböhler. Courtesy: Kasmin, New York

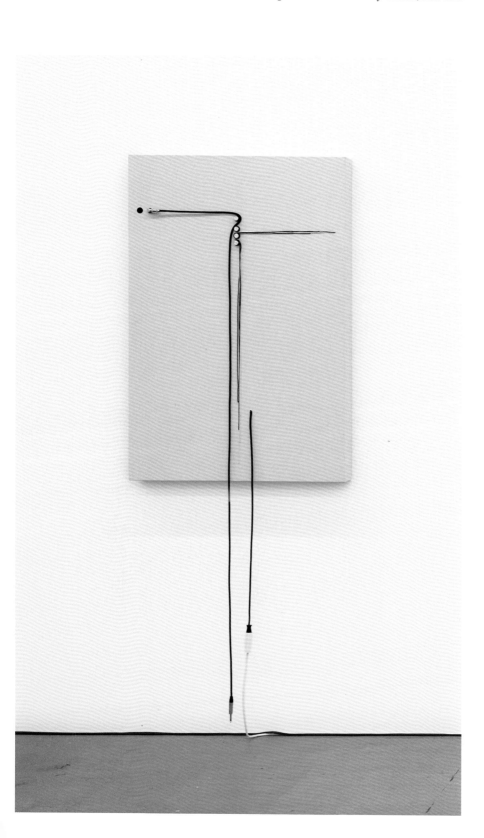

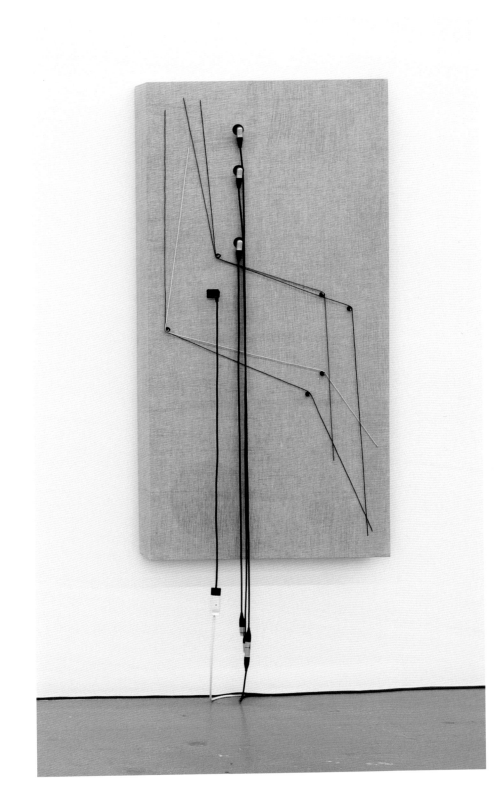

...nsition, 2016. Wood, canvas, cables, disassembled Behringer Eurolive F1220D powered speaker (knobs, wires, circuit board, ports, ...aker). Installation view at Kunsthaus Baselland, Muttenz / Basel, 2018. Photo: Serge Hasenböhler. Courtesy: Kasmin, New York

INSTRUMENTS WITH NO MASTER

Zoe Lukov

e act of smashing the electric guitar is a thing—a big, climactic, performative, macho thing. We have seen it over and over again, this act of male anarchy and destruction. Its occurrence might have arguably changed rock 'n' roll forever. Pete Townshend, from the band The Who, was the first to break a guitar onstage, but the act has been repeated and memorialized by many great rock 'n' roll musicians, from Jimi Hendrix to Kurt Cobain and beyond. Naama Tsabar records the breaks. *Melodies of Certain Damage (Opus 2)* (2018), presented at Faena Art Center Buenos Aires in September 2018, was her first exhibition in Argentina and her largest-scale installation of this latest body of work, which utilizes broken guitars as prime material for the creation of new sculptural and sonic installations that occupy the in-between, or the hazy area between contemporary art and musical practices—the interstitial zone between object and subject, the amorphous space between performance, process, and sculpture.

ppropriating this iconic and overtly macho trope, Tsabar breaks guitars, but not for the public—and the act is not the climax but rather the process, the beginning of the creation. The death of the object becomes the starting point of the new project. The *Melody of Certain Damage* series (2018–ongoing) is both a document of her destruction of these guitars and, ultimately, a proposition for a new kind of instrument, a new sound, and a way of moving forward for a new creation. She repurposes the remnants of an act of male bravado and violence, reimagining the broken pieces as objects of visual and functional significance. Inserting them back into a new working order, Tsabar makes the remains of what once was into instruments in their own right.

this new landscape, the guitar becomes a relic, denied its previous existence as a reified object within a hegemonic performance structure. The once phallic object, intended to be held and played in a specific way and then destroyed in one climactic and almost sexually explicit moment, is now a field of shattered pieces, scattered throughout the space, restrung and tenuously transformed into a new territory for the performers to insert themselves into.

hese sculptures are maps for the memory of the damage. There is something totemic about the electric guitar destroyed by the artist in a private, ritual sacrifice—a channeling of energy toward the moment of sculptural creation that might be seen like a clearing or a cleansing, or a suggestion for future healings of the individual body and communal social body out of the wreckage and the violence.

he antihierarchical structure of these installations necessitates a shift in the gaze and in perspective—a multiplicity of viewpoints with no centrality. The public can touch the works and move through them—a variation on the communal gathering experience and a new radical and disruptive mode for public engagement with sculpture and sound that inverts the well-established relationships between performer and viewer, between the audience and the venue, and between the object and its activator.

t is important to note that in her research, Tsabar has not found one recorded instance of a female musician breaking a guitar—not even an instance in which it was written about. This body of work implies a shifting of the record and the recordkeepers. The *Melody of Certain Damage* series might be viewed as the natural progression

of a body of work that Tsabar calls the *Guitar* series—works that explore the instrument as object and framework for performance by inventing new ways of engaging with its inherent an applied power and symbolism. Arguably, it was Tsabar's series *Composition* (2006–ongoing) that allowed for the first large-scal explorations of the guitar and how to segment and disorient wha was previously a unified sound. The works at this time were gu tar-centric but insisted on a dispersion of sound along news lin drawn by new radical communities of musicians gathered by Tsabar. They created new compositions, dictated by their own skill sets and bodies, that would fit within her broader structure becoming a field of sound of sorts that was both a physical and sonic installation and experience, with the guitar and the song structure as its organizing principal. As the public traverse the "fields of sound," they are moved through the composition both temporally and physically—there is no center, and the source o power shifts and disperses. The guitar solo gives way to a crow sourced composition and a new kind of sonic landscape.

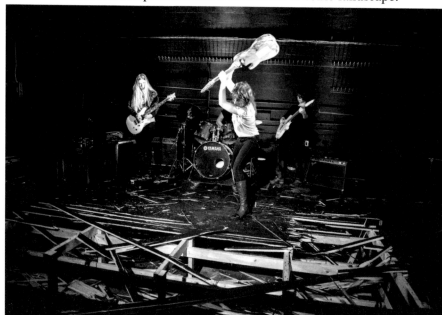

Untitled (Babies), 2010–ongoing. Performed by Alejandra Campos, Sally Gates, Carolina Souto, and Naama Tsabar. Performance view at Auto Body Miami at Giant Motors, 2014. Photo: Monica McGivern. Courtesy: Spinello Projects, Miami

Tsabar's seminal work *Untitled (Babies)* (2008) was her earliest engagemen with what the gesture of the guitar break could mean for female identified performers. In this work, Naama plays the song "Babie (1994) by the all-male British rock band Pulp. In Tsabar's mout the lyrics of young, masculine sexual awakening and desire are flipped—the entire performance is a kind of drag, a radical quee repurposing of Jarvis Cocker's already cheeky declarations of lov "I want to take you home. I want to give you children. You migl be my girlfriend, yeah," sings Tsabar onstage with her band of a women, when what at first appears to be an attempt to smash the guitar becomes instead a tiring, back-breaking exercise and durational performance that leaves the floor in shreds. A gaping yawning void in the stage appears ready to swallow the band, while the monolithic guitar remains entirely intact. The break i the stage was perhaps the first time Tsabar posed the question, and ultimately, the *Melody of Certain Damage* series is perhaps

her response to this initial proposition. While the performance can only happen once, the action is captured on video, preserved in a style that exists somewhere between documentation of 1970s performance art and a 1990s music-video edit—a documentation of not just the stage's destruction but of what it might look like to punctuate the very platform of rock 'n' roll, to put a hole in the foundations upon which we stand, to leave room for new questions to emerge within a hegemonic structure.

ailarly, *Untitled (Double Face)* (2010) continued Tsabar's line of inquiry by challenging the nature of the guitar as a solo instrument. She doubles the guitar neck so that it now exists as an instrument for two. The work expresses itself within a system of handicap: there is the necessity for another in order for sound to be produced. In this case, the performance between Tsabar and her collaborator for the double-guitar becomes a negotiation of movement, strength and sound. The work is an expression of relationship and of intimacy. The performers mirror and double each other as the object itself demands a codependent but ultimately collaborative, creative process—the handicap imposed by the object becomes generative.

lodies of Certain Damage (Opus 2) continues to move away from concepts of the soloist or lone genius composer. The composition written on the sculptures, within the installation, is a collaborative piece by female-identified musicians and performers—some of whom have worked with Tsabar previously, others new collaborators— that was created on-site in Buenos Aires during a one-week residency. These instruments have no masters, no teachers; they come with no rules for how to play them, and each performer brings her own particular musical history and training. The sensuality with which the female-identified musicians play these instruments, lying with them in a kind of post-coital intimacy on the floor, gives the works their new lives. What might be seen as a position of servitude or vulnerability on the floor for the performer becomes a position of empowerment, both with the objects and other performers. Tsabar's refusal to engage with the monumentality of the Faena Art Center is a transgressive act that shifts the gaze and our understanding of the lines of power—a decolonizing of the ground beneath us that necessitates a reevaluation of traditional performance hierarchy in a way that is less centric, more amorphous and dispersed—toward a new disorder.

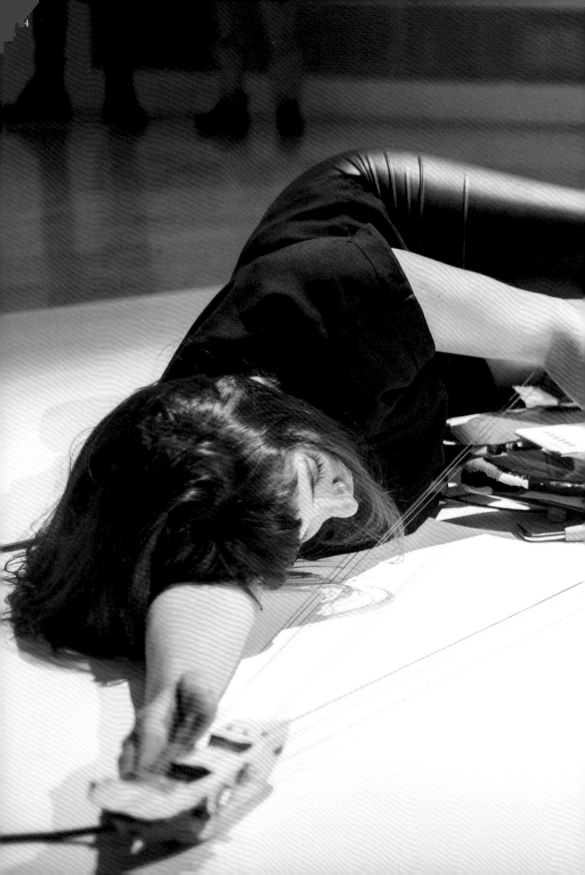

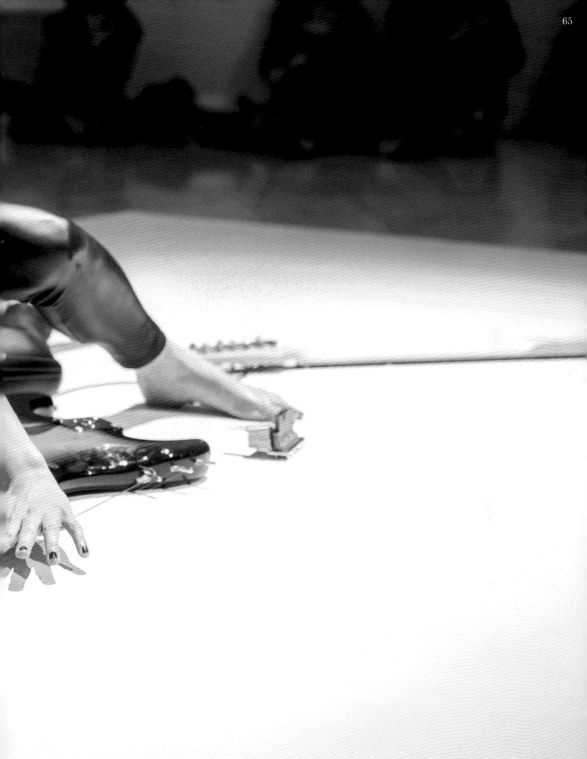

Melodies of Certain Damage (Opus 2), 2018. Composed and performed by Gabriela Areal, Rose Blanshei, Florencia Curci, Violeta García, Luciana Rizzo, Natalia Spiner, Sarah Strauss, Naama Tsabar, and Carola Zelaschi. Performance view at Faena Art Center Buenos Aires. Photo: Jorge Miño. Courtesy: Faena Art Center Buenos Aires

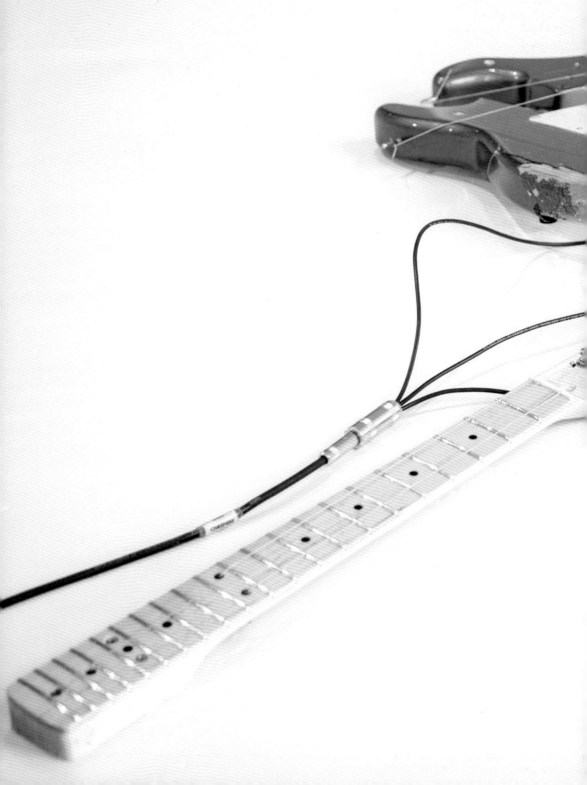

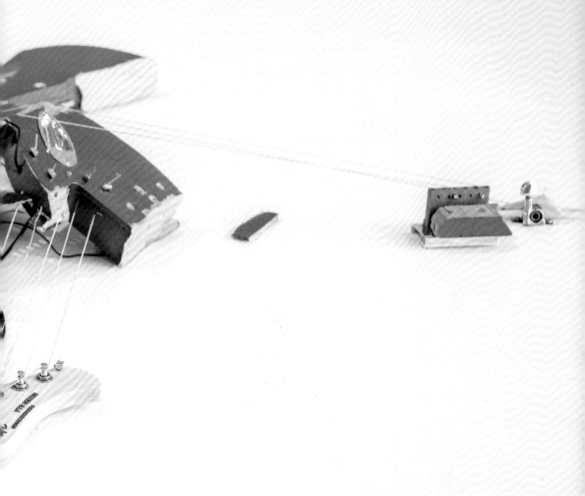

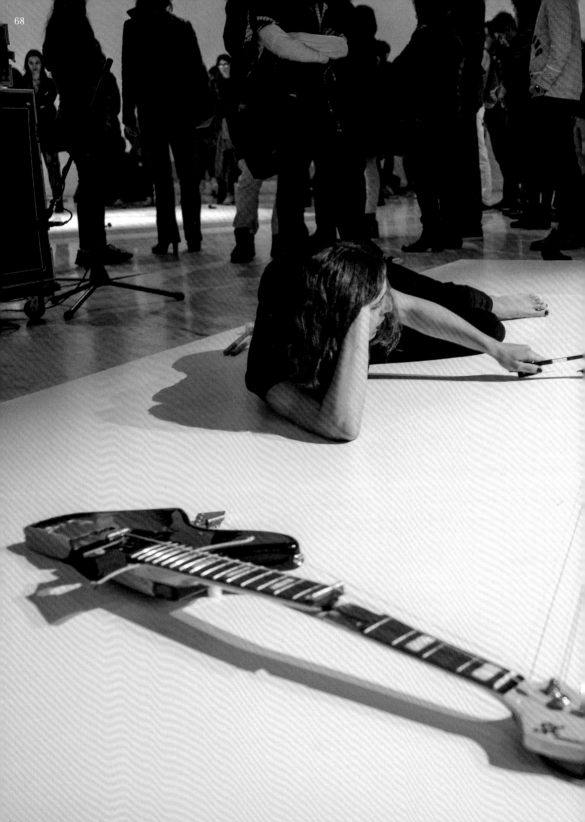

Melodies of Certain Damage (Opus 2), 2018. Composed and performed by Gabriela Areal, Rose Blanshei, Florencia Curci, Violeta García, Luciana Rizzo, Natalia Spiner, Sarah Strauss, Naama Tsabar, and Carola Zelaschi. Performance view at Faena Art Center Buenos Aires. Photo: Jorge Miño. Courtesy: Faena Art Center Buenos Aires

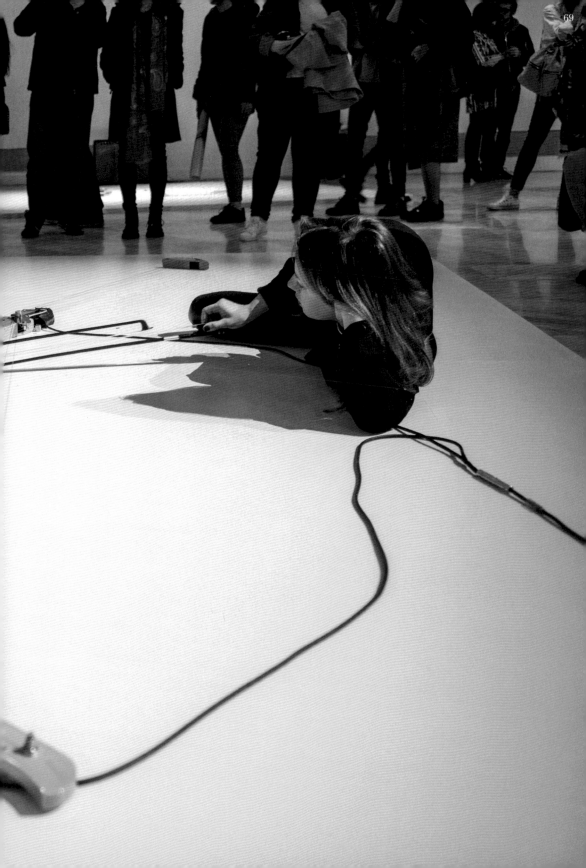

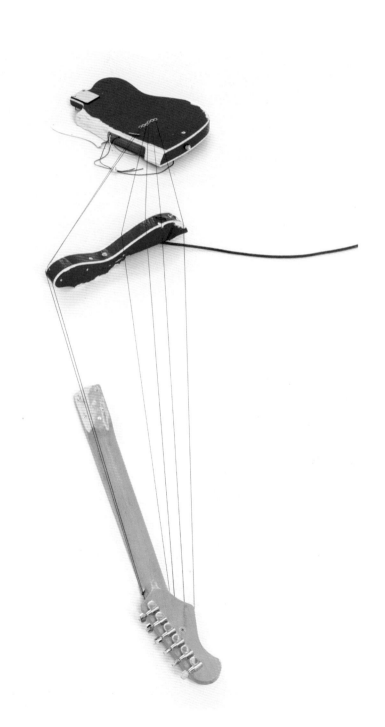

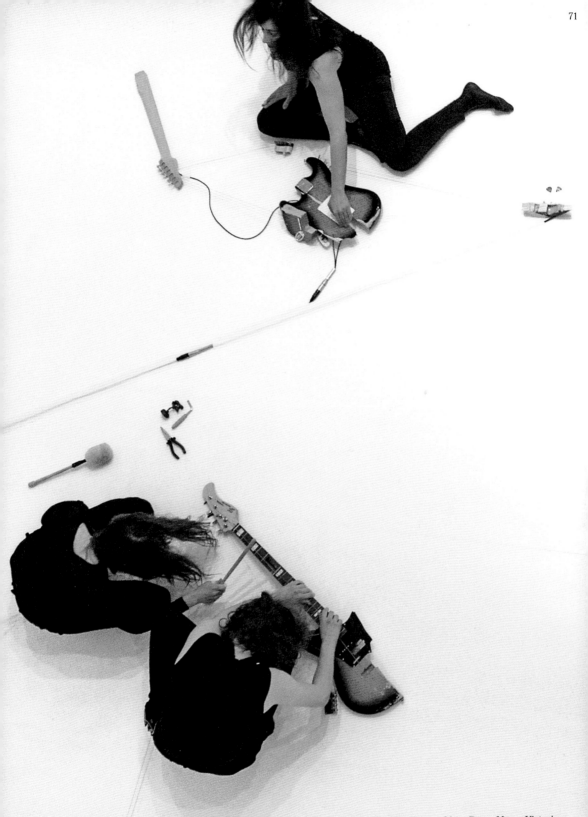

Melodies of Certain Damage (Opus 3), 2018. Composed and performed by Rotem Frimer, Nina Loeterman, Maya Perry, Moran Victoria Sabbag, Sarah Strauss, and Naama Tsabar. Performance view at CCA – Center for Contemporary Art Tel Aviv. Photo: Eyal Agivayev. Courtesy: CCA – Center for Contemporary Art Tel Aviv

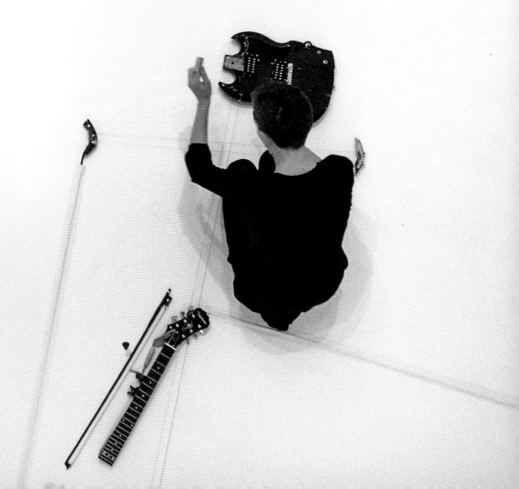

Body of Certain Damage #8, 2018. Broken electric guitar, strings, microphone, screws and amplifier. Installation view at Faena Art Center Buenos Aires. Photo: Loló Bonfanti. Courtesy: the artist

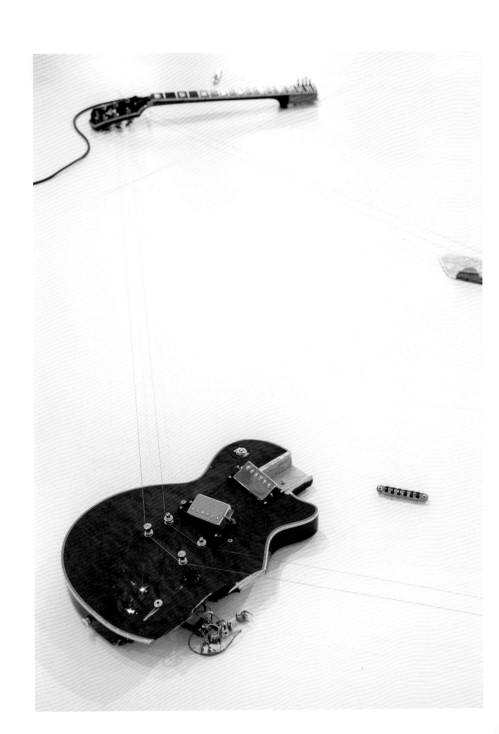

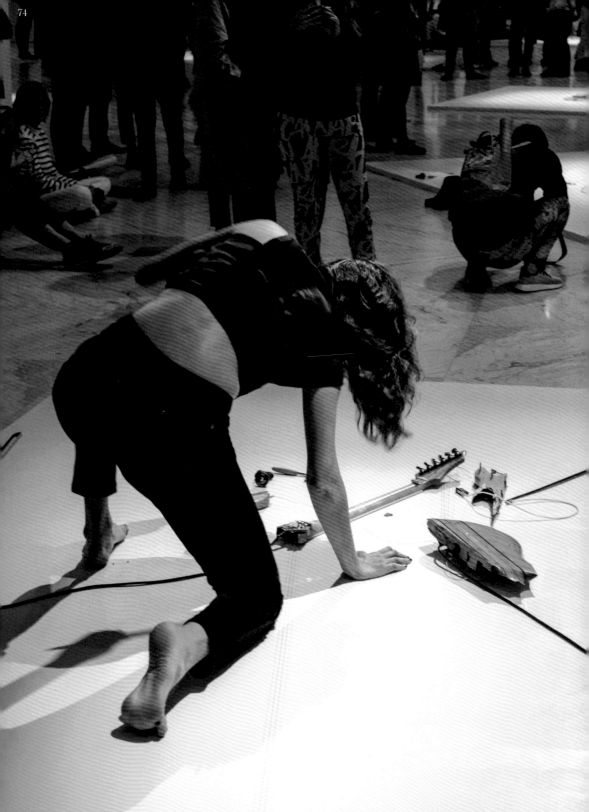

Melodies of Certain Damage (Opus 2), 2018. Composed and performed by Gabriela Areal, Rose Blanshei, Florencia Curci, Violeta García, Luciana Rizzo, Natalia Spiner, Sarah Strauss, Naama Tsabar, and Carola Zelaschi. Performance view at Faena Art Center Buenos Aires. Photo: Jorge Miño. Courtesy: Faena Art Center Buenos Aires

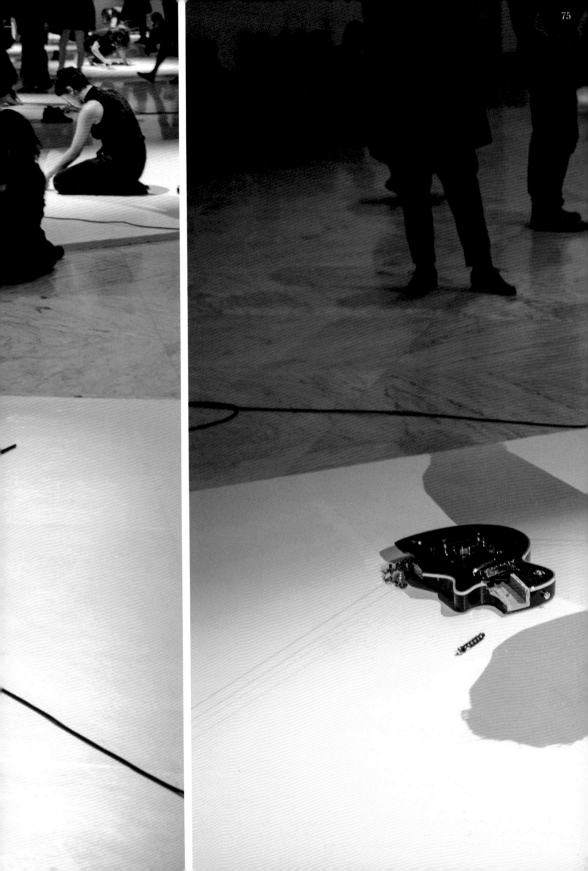

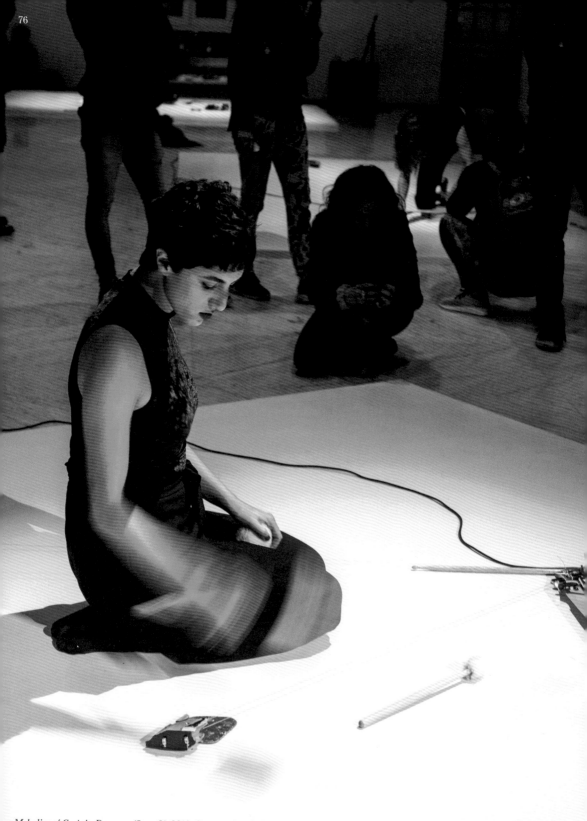

Melodies of Certain Damage (Opus 2), 2018. Composed and performed by Gabriela Areal, Rose Blanshei, Florencia Curci, Violeta García, Luciana Rizzo, Natalia Spiner, Sarah Strauss, Naama Tsabar, and Carola Zelaschi. Performance view at Faena Art Center Buenos Aires. Photo: Jorge Miño. Courtesy: Faena Art Center Buenos Aires

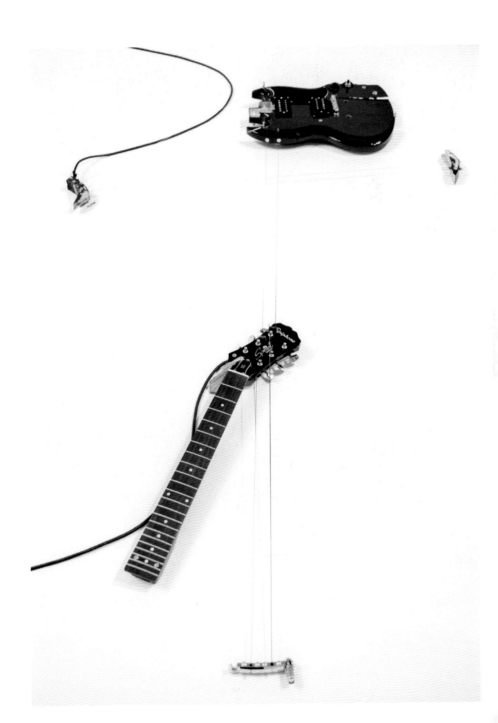

Body of Certain Damage #10, 2018. Broken electric guitar, strings, microphone, screws and amplifier. Installation view at Faena Art Center Buenos Aires. Photo: Loló Bonfanti. Courtesy: the artist

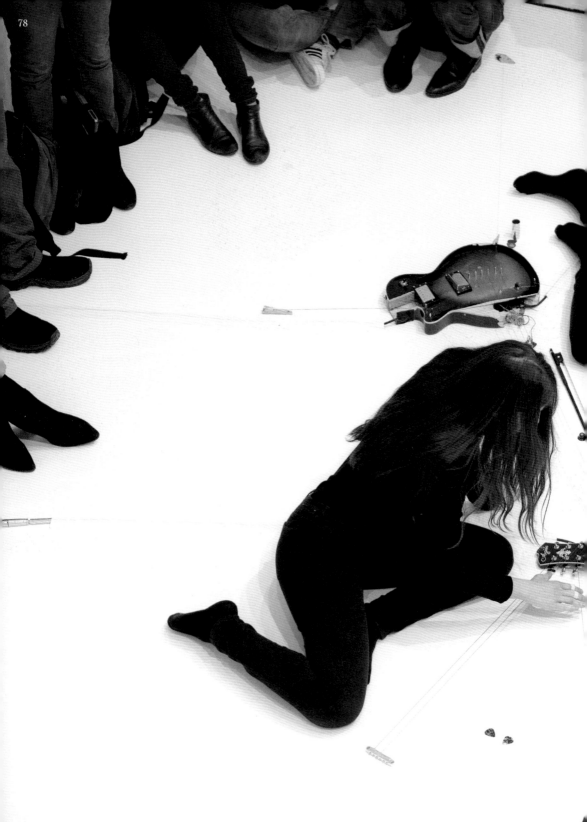

Melodies of Certain Damage (Opus 3), 2018. Composed and performed by Rotem Frimer, Nina Loeterman, Maya Perry, Moran Victoria Sabbag, Sarah Strauss, and Naama Tsabar. Performance view at CCA – Center for Contemporary Art Tel Aviv. Photo: Eyal Agivayev. Courtesy: CCA – Center for Contemporary Art Tel Aviv

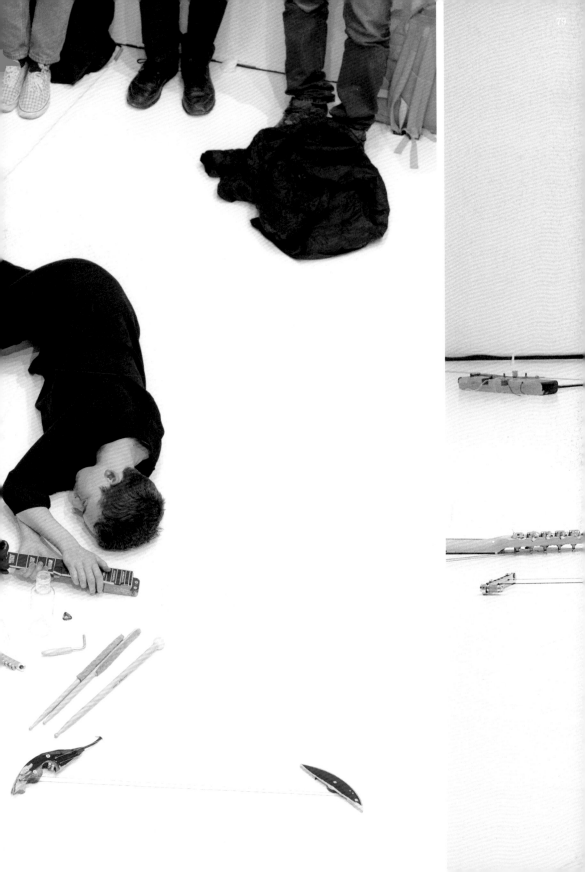

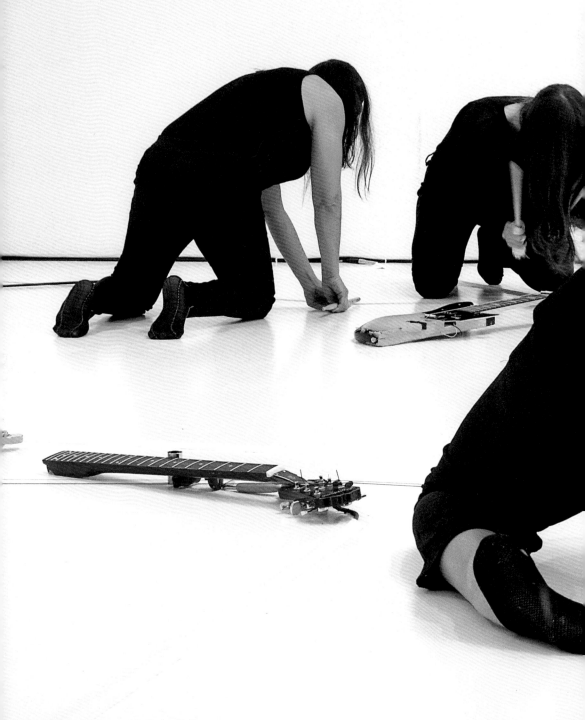

Melodies of Certain Damage (Opus 3), 2018. Composed and performed by Rotem Frimer, Nina Loeterman, Maya Perry, Moran Victoria Sabbag, Sarah Strauss, and Naama Tsabar. Performance view at CCA – Center for Contemporary Art Tel Aviv. Photo: Eyal Agivayev. Courtesy: CCA – Center for Contemporary Art Tel Aviv

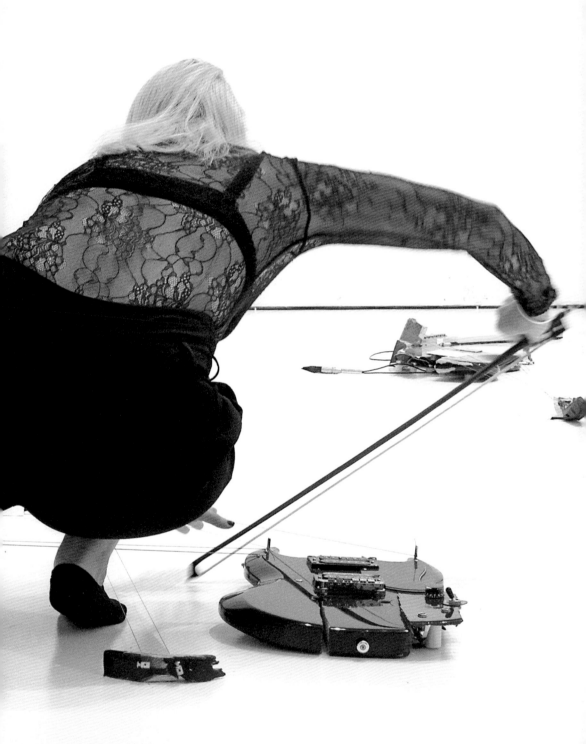

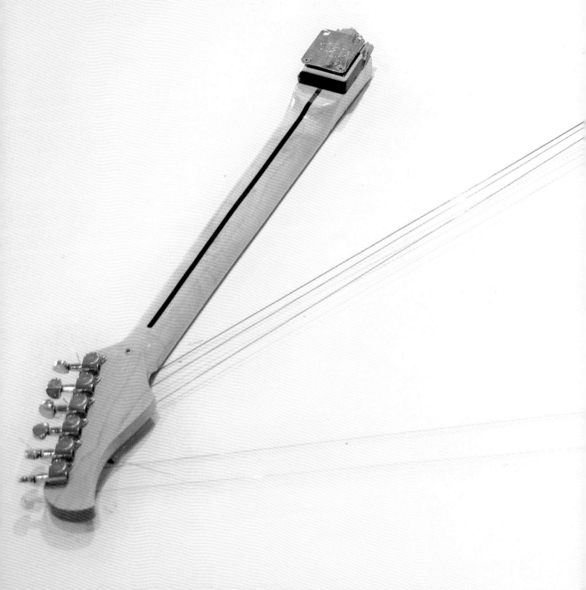

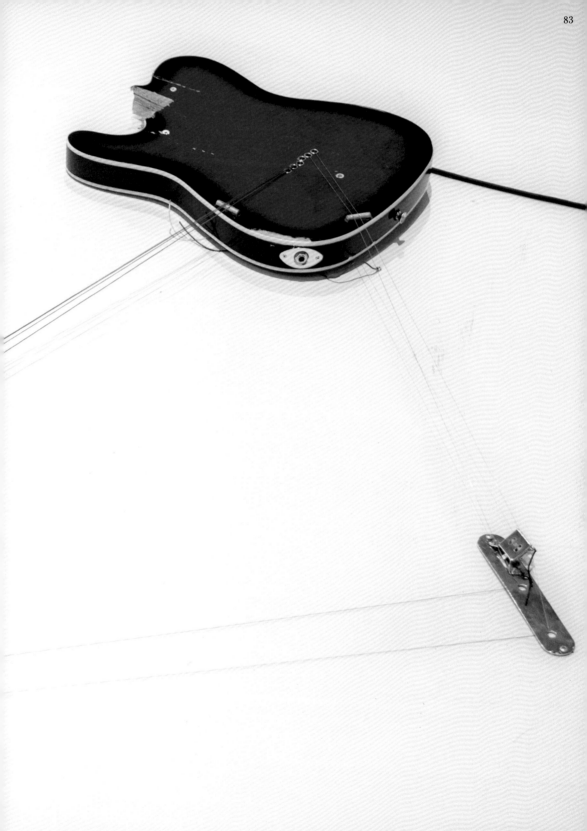

Melody of Certain Damage #6, 2018. Broken electric guitar, strings, microphone, screws and amplifier. Installation view at Faena Art Center
Buenos Aires. Photo: Loló Bonfanti. Courtesy: the artist

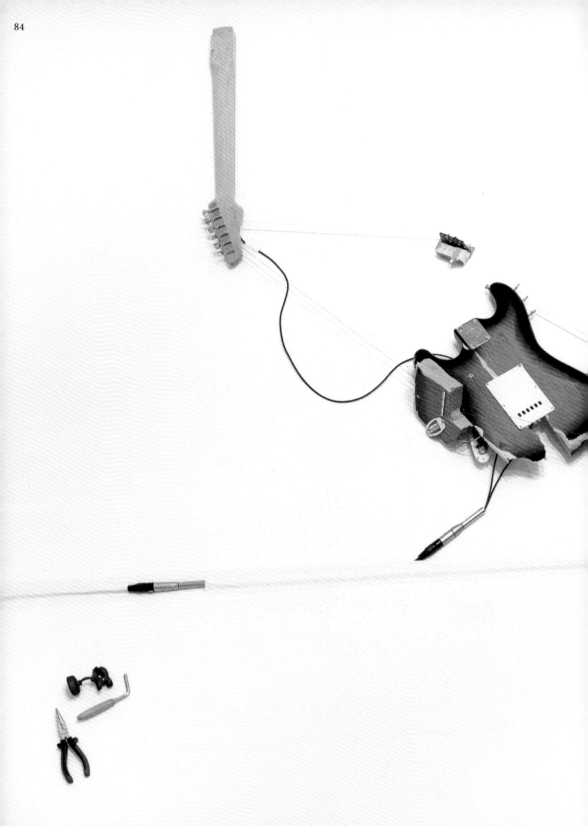

Melodies of Certain Damage (Opus 3), 2018. Composed and performed by Rotem Frimer, Nina Loeterman, Maya Perry, Moran Victoria Sabbag, Sarah Strauss, and Naama Tsabar. Performance view at CCA – Center for Contemporary Art Tel Aviv. Photo: Eyal Agivayev. Courtesy: CCA – Center for Contemporary Art Tel Aviv

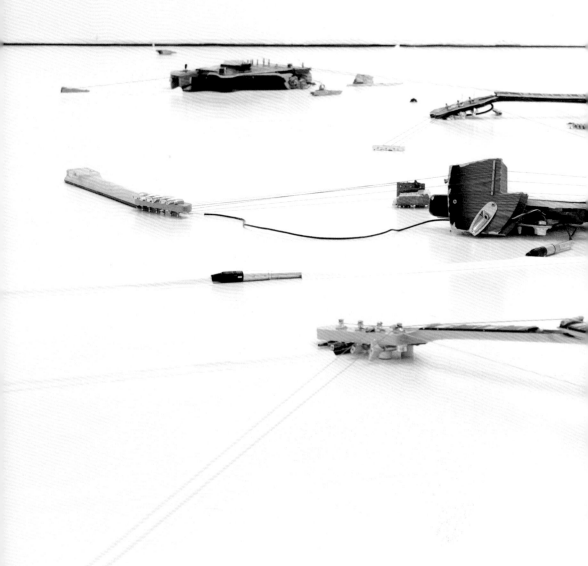

Melodies of Certain Damage (Opus 3), 2018. Exhibition view at CCA – Center for Contemporary Art Tel Aviv. Photo: Eyal Agivayev

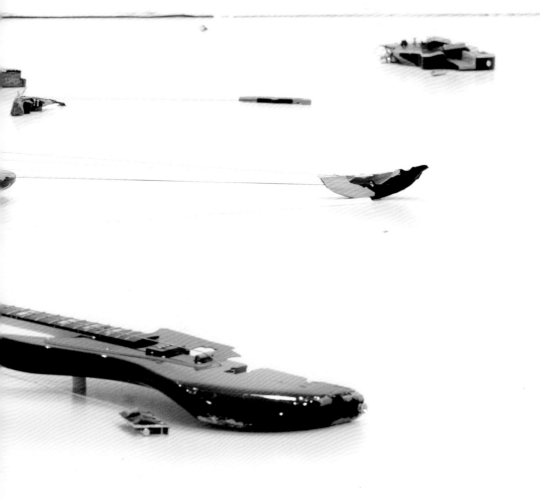

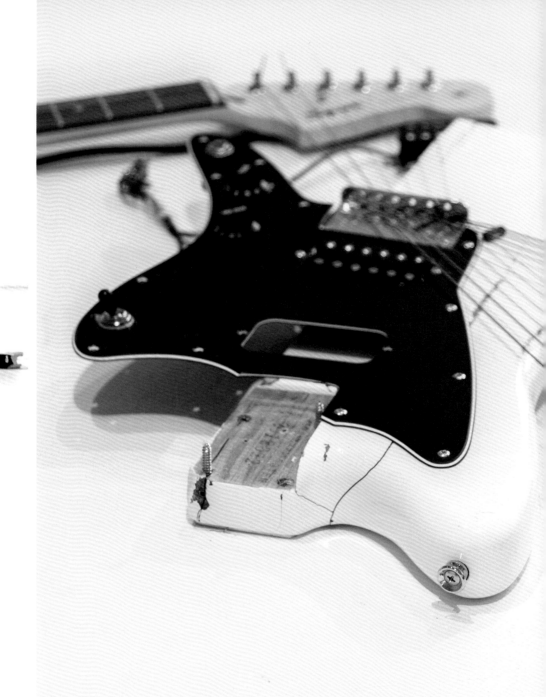

Melody of Certain Damage #9, 2018. Broken electric guitar, strings, microphone, screws and amplifier. Installation view at Faena Art Cente Buenos Aires. Photo: Loló Bonfanti. Courtesy: the artist

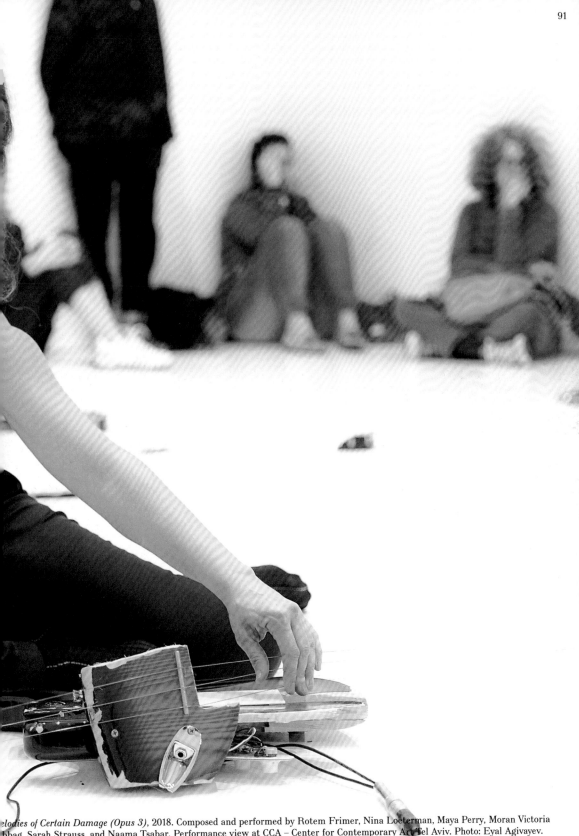

elodies of Certain Damage (Opus 3), 2018. Composed and performed by Rotem Frimer, Nina Loeterman, Maya Perry, Moran Victoria bbag, Sarah Strauss, and Naama Tsabar. Performance view at CCA – Center for Contemporary Art Tel Aviv. Photo: Eyal Agivayev. urtesy: CCA – Center for Contemporary Art Tel Aviv

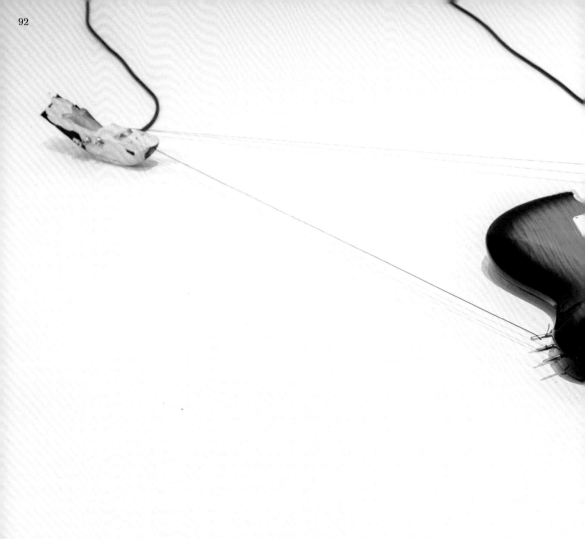

Melody of Certain Damage #5, 2018. Broken electric guitar, strings, microphone, screws and amplifier. Installation view at Faena Art Cent
Buenos Aires. Photo: Loló Bonfanti. Courtesy: the artist

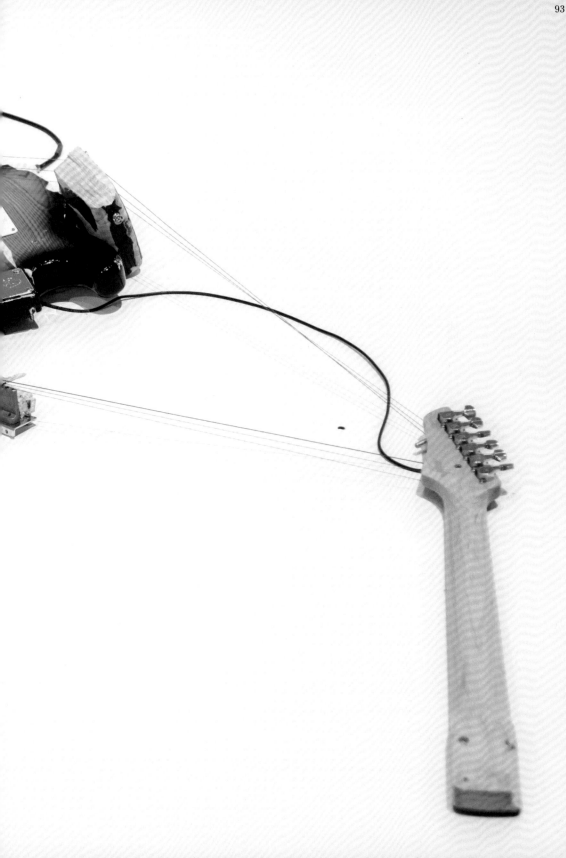

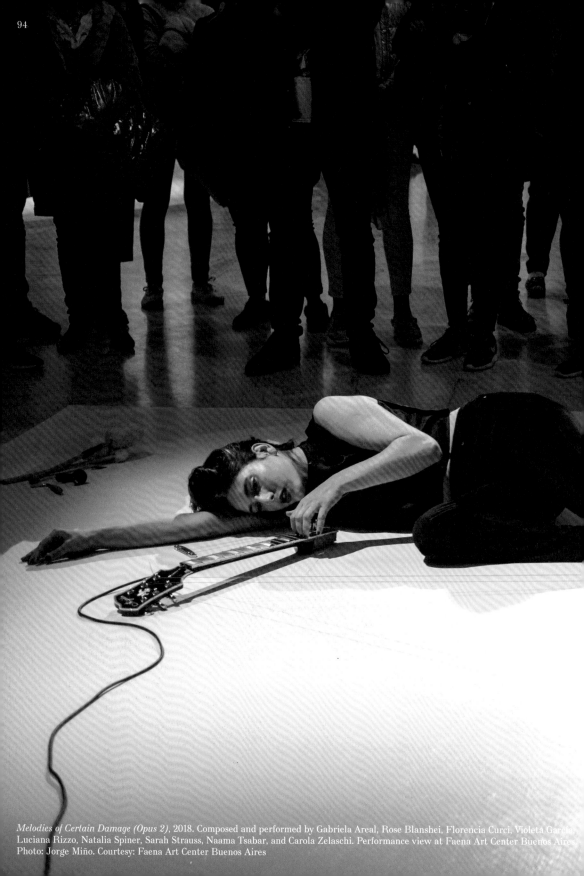

Melodies of Certain Damage (Opus 2), 2018. Composed and performed by Gabriela Areal, Rose Blanshei, Florencia Curci, Violeta García, Luciana Rizzo, Natalia Spiner, Sarah Strauss, Naama Tsabar, and Carola Zelaschi. Performance view at Faena Art Center Buenos Aires. Photo: Jorge Miño. Courtesy: Faena Art Center Buenos Aires

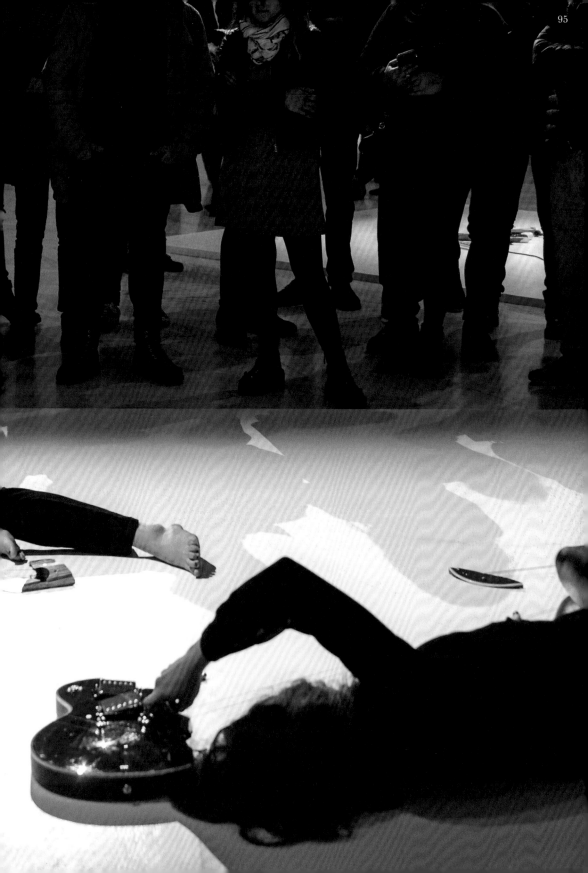

POLYPHONIC POLITICS

Zoe Lukov

e rhizome is reducible to neither the One nor the multiple. [...]
is composed not of units but of dimensions, or rather directions
motion. It has neither beginning nor end [...]. Unlike a structure,
ich is defined by a set of points and positions, [...] the rhizome
made only of lines, [...] the rhizome pertains to a map that must be
oduced, constructed, a map that is always detachable, connectable,
versible, modifiable, and has multiple entryways and exits.[1]
—Gilles Deleuze and Félix Guattari

Buenos Aires, in the neighborhood of Puerto Madero, all the streets are
named after women. The Faena Art Center, which hosted Naama
Tsabar's exhibition *Melodies of Certain Damage (Opus 2)* in 2018,
is on Aimé Painé, between Azucena Villaflor and Juana Manso.
Manso was arguably Argentina's first feminist. She was a writer
and educator who founded the journal "Album de señoritas.
Periódico de literatura, modas, bellas artes y teatros" in 1854,
and was one of the first voices in the country arguing for gender
equality. As a friend to Domingo Sarmiento, the first president
of the republic, she was instrumental in the founding of many
of the nation's libraries. Aimé Painé was a Mapuche singer whose
legal name was Olga Elisa because indigenous names were still
not recognized by the government when she was born in 1943.
She never recorded an album, but became one of the most well-
known musicians of her time for reclaiming folkloric sounds, trav-
eling the world as an ambassador of indigenous music, and for her
activism on behalf of Mapuche people. Azucena Villaflor was one
of the founders of the Mothers of the Plaza de Mayo in 1977, when
she and thirteen other mothers staged weekly demonstrations to
protest the abduction and disappearance of their children at the
hand of the military dictatorship in the prior years. The mothers
marched every Thursday in the Plaza de Mayo wearing white
handkerchiefs and carrying images of their lost children. Less
than a year later, Villaflor was also disappeared, but not before
she had set the stage for a protest movement that amplified the
fact of motherhood and maternity as a shield and means of power.
is with this history and within this context that Israeli-born New York–
based artist Naama Tsabar arrived in Buenos Aires in the first
week of September 2018, less than one month after the Argentine
senate had voted down a bill that would have finally legalized
abortion. The vote against legalizing abortion came in the midst
of an economic downturn that left the country reeling and the
peso devalued by almost fifty percent in one month; the vote
came only a few months after the second national strike, on
International Women's Day, led by the group #NiUnaMenos,
which started in 2015 to protest the murder of fourteen-year-old
Chiara Paez, who became a symbol for country's high rates of
femicide. Like the Madres de Plaza de Mayo movement, the
current women's movement is known for its handkerchiefs, but
rather than being white as a symbol of the purity of maternity,
the handkerchiefs are now green, the national color for legal
abortion, gender equality, and self-determination over one's body.
abar had to cast her performers from a distance: she had never been to
Argentina, had not made music or art in this context, had not
yet experienced the country's feminism. For *Melodies of Certain
Damage (Opus 2)*, she put out a call for female and gender

nonconforming musicians, especially drummers, guitar players, bass players, and players of other stringed instruments (cello, violin, viola, etc.), to participate in an experimental performanc as part of an art installation. Musicians sent videos or audio cli of their work and Tsabar selected six female-identified performe She brought two longtime collaborators with her, and she arriv eight days prior to the exhibition opening for an intensive work shop residency with this new "band."

A new site-specific sound installation made in collaboration with musician one has never met is a bold proposition and requires a new mod for thinking about how to compose music, play it, and create a cohesive performance. It is not only about new states of play and collaboration but also about the creation of new knowledg Tsabar's instruments have no models, have never existed in any known form prior to their creation—they have never been prac ticed on; there are no workbooks, instruction manuals, or YouTu video tutorials from which one can learn how to play. Musician and composer alike must invent a new vocabulary. Tsabar's smashed, dismantled, reconfigured, and retuned guitars—which some may see as "broken," disadvantaged, or unusable—allow for infinite possibilities. Restructured, these guitars are now fre from previously ordained concepts; they are liberated from set ideas one might have about tonality, melody, or harmony.

Rehearsal for *Melodies of Certain Damage (Opus 2)*, composed and performed by Gabriela Areal, Rose Blanshei, Florencia Curci, Violeta García, Luciana Rizzo, Natalia Spiner, Sarah Strauss, Naama Tsabar, and Carola Zelaschi at CHELA, Buenos Aires, 2018. Photo: Loló Bonfanti

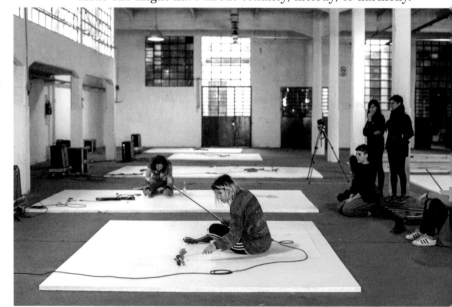

The workshop started with three five-hour days of structured play—a gene ous offering of space for exploration. It allowed for synergies to develop as the individual musicians identified their own sounds and the intersections that existed with other performers' freque cies. The workshops were nonhierarchical yet controlled enviro ments that encouraged absolute respect among the musicians a total freedom for play, for listening, and for dialogue. Inherentl informed by their individual experiences in music and in life, ea performer charms and ignites these new instruments in a uniqu way, contributing to a future composition.

Tsabar recorded everything on video and then reviewed the footage both alone and with the musicians. The group began to identify piec

and elements that worked, and made a selection that became the basis for exercises and practice. By the fourth day, individual elements, movements, and sounds were integrated into a pattern that could be rehearsed and played until finally a full opus emerged. Each musician's individuality provided a unique contribution to the overall composition that ultimately gave way to a rhizomatic process of mapping sound that grows across multiple lines of inquiry, contains no center, and negates concepts of authorship in the traditional sense. In this case, the process of play is as important and radical as the final, collectively created composition.

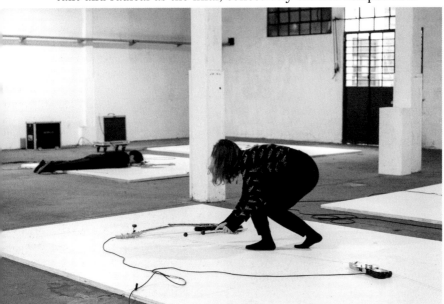

Rehearsal for *Melodies of Certain Damage (Opus 2)*, composed and performed by Gabriela Areal, Rose Blanshei, Florencia Curci, Violeta García, Luciana Rizzo, Natalia Spiner, Sarah Strauss, Naama Tsabar, and Carola Zelaschi at CHELA, Buenos Aires, 2018. Photo: Loló Bonfanti

s Loló Bonfanti, performance photographer and member of the production team, commented based on her experience in the process, "Naama was able to capture something from this experimental and chaotic new universe and organize it beautifully, allowing for the different personalities of each artist to emerge—the smooth eroticism of Luciana Rizzo's sounds, the power of the dry smacks created by Gabriela Areal, the delicacy in Natalia Spiner and Sarah Strauss's melody, Carola Zelaschi's concrete punk rhythm, the bow-dance of Violeta García and Rose Blanshei, the way Florencia Curci found and filled in the missing sounds. [...] The small, individual universes of each performer came to create the entire opus [...] a utopia of cooperation made reality."

'ith their fingernails painted green for the opening performance, in solidarity with their peers marching in the streets of Buenos Aires, and together with the ghosts of the past and informed by countless women before them—with Painé's songs, Villaflor's handkerchief, Manso's writing—this group of women made *Melodies of Certain Damage (Opus 2)*, lending their voices and their bodies to a new composition and, in doing so, contributing to the power of an entire movement.

1. Gilles Deleuze and Félix Guattari, *A Thousand Plateaus: Capitalism and Schizophrenia*, (Minneapolis: University of Minnesota Press, 1987), 21.

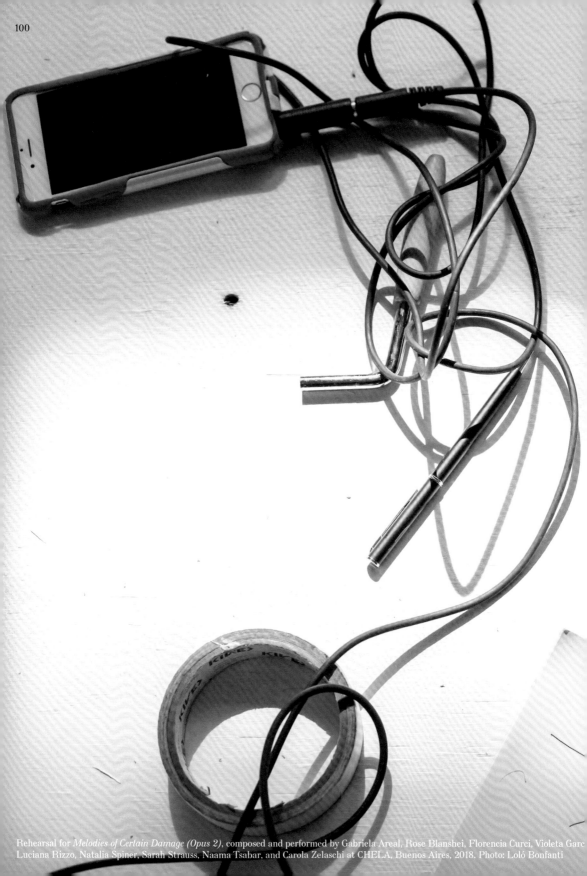

Rehearsal for *Melodies of Certain Damage (Opus 2)*, composed and performed by Gabriela Areal, Rose Blanshei, Florencia Curci, Violeta Garc
Luciana Rizzo, Natalia Spiner, Sarah Strauss, Naama Tsabar, and Carola Zelaschi at CHELA, Buenos Aires, 2018. Photo: Loló Bonfanti

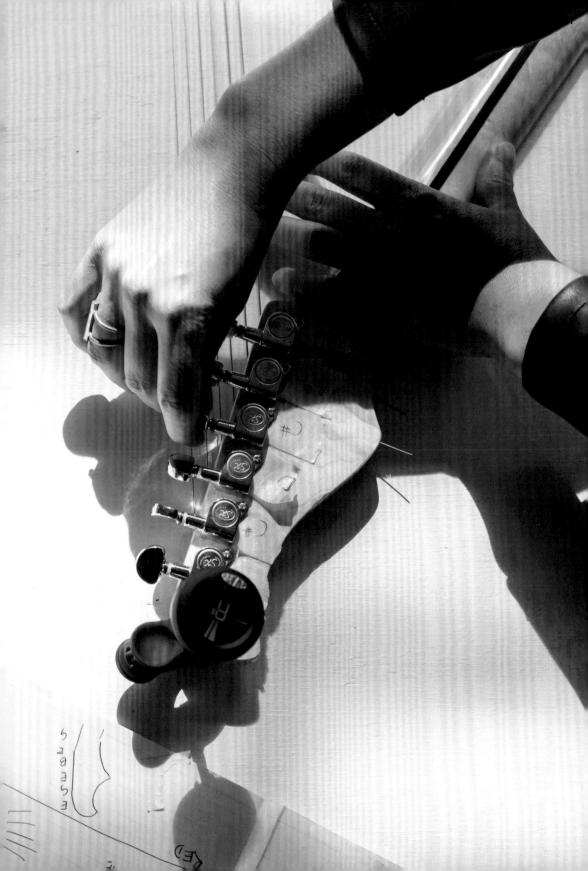

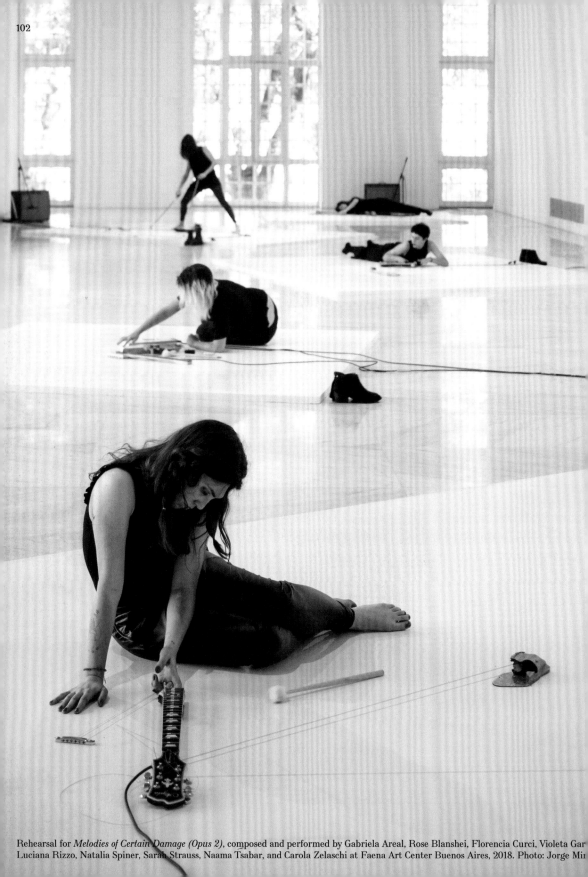

Rehearsal for *Melodies of Certain Damage (Opus 2)*, composed and performed by Gabriela Areal, Rose Blanshei, Florencia Curci, Violeta Gar
Luciana Rizzo, Natalia Spiner, Sarah Strauss, Naama Tsabar, and Carola Zelaschi at Faena Art Center Buenos Aires, 2018. Photo: Jorge Mir

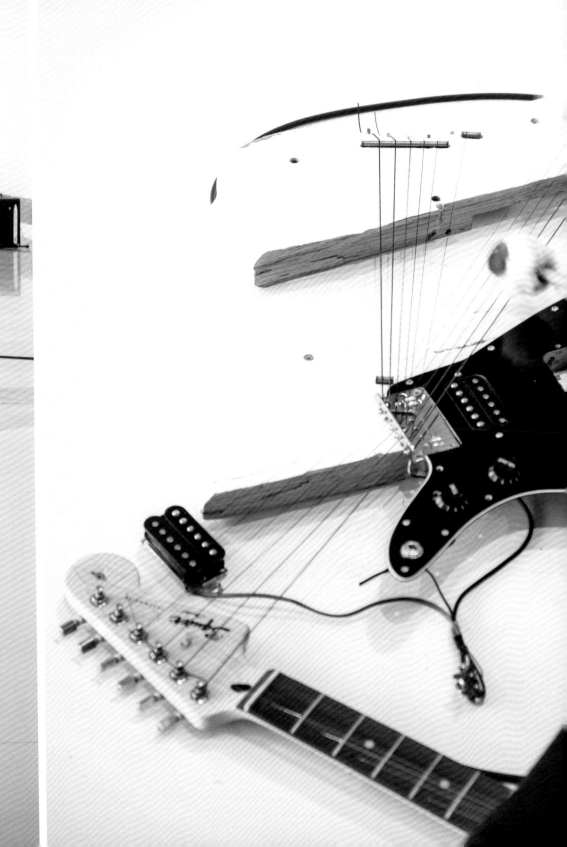

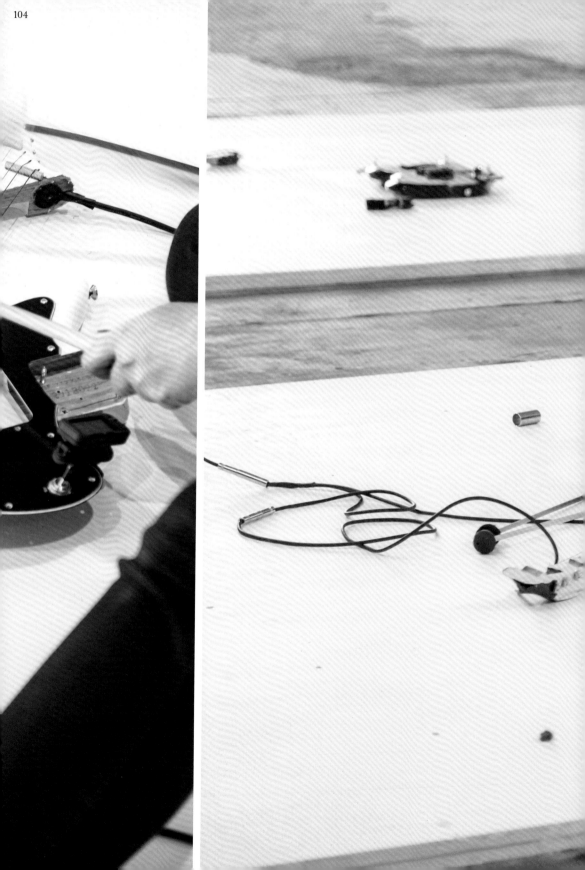

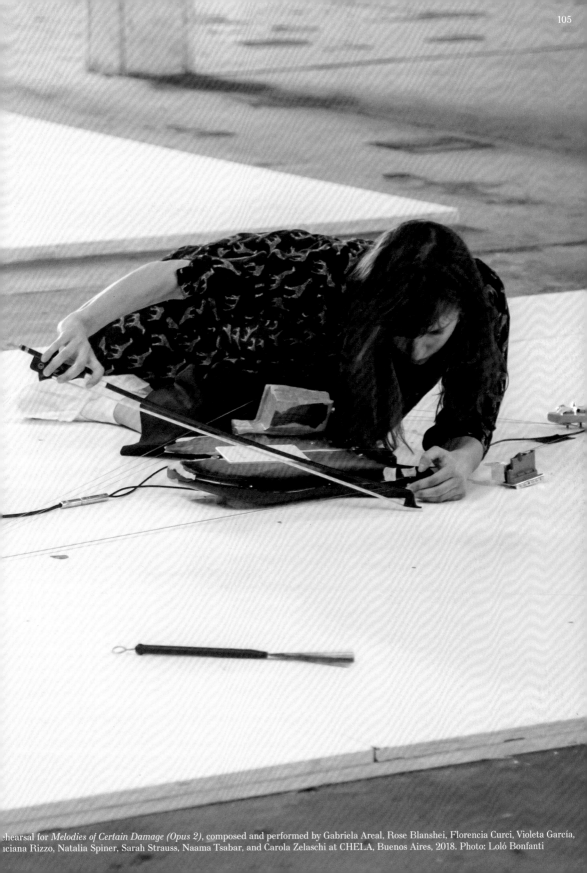

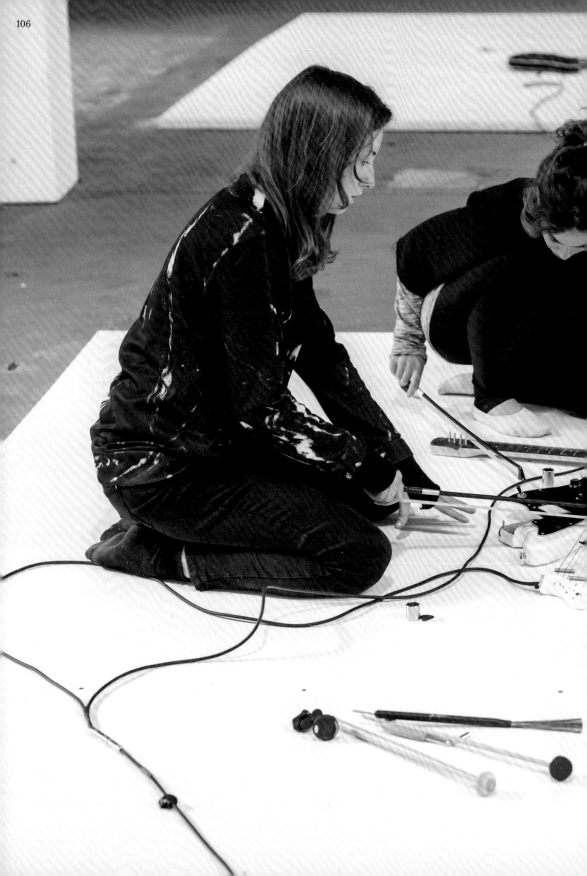

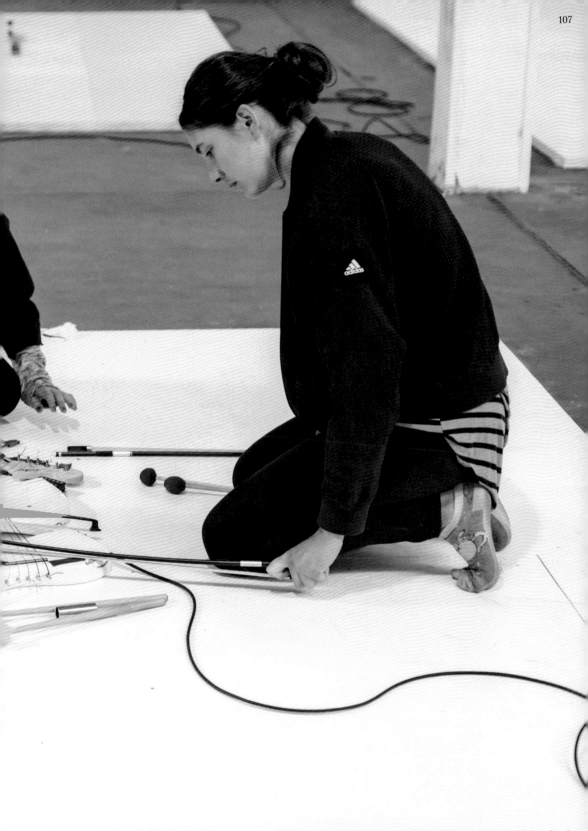

Rehearsal for *Melodies of Certain Damage (Opus 2)*, composed and performed by Gabriela Areal, Rose Blanshei, Florencia Curci, Violeta García, Luciana Rizzo, Natalia Spiner, Sarah Strauss, Naama Tsabar, and Carola Zelaschi at CHELA, Buenos Aires, 2018. Photo: Loló Bonfanti

Naama Tsabar.
Melodies of Certain Damage (Opus 2)

September 6–8, 2018
Curated by Zoe Lukov

Faena Art Center Buenos Aires
Aimé Painé 1169 Puerto Madero
Buenos Aires, Argentina
faenaart.org

Board
German de Elizalde (President),
Neisen Kasdin (Secretary), Sarah Arison,
Olga Blavanik, Gita Shamdasani
Executive Director
Nicole Comotti
Chief Curator
Zoe Lukov
Director of Exhibitions
Direlia Lazo
Executive Producer
Cecilia Kuska
Exhibition Coordinator
Loló Bonfanti
Production Manager
Alejandro Porta Fracchia
Art Director
Laura Suhs
Coordinator
Elizabeth Blotta
Creative Design Director
Mariana Pariani
Editorial Director
Gaston Guaglianone
Designers
Alejandra Román, Sean Mac Allister,
Sebastián Gagin
Graphic Designer
Karina de León

Faena Art Center Buenos Aires
is supported by Banco Ciudad.

The exhibition was supported by
DS Automobiles and the Embassy
of Israel in Buenos Aires.

Melodies of Certain Damage (Opus 2),
composed and performed by
Gabriela Areal, Rose Blanshei,
Florencia Curci, Violeta García,
Luciana Rizzo, Natalia Spiner,
Sarah Strauss, Naama Tsabar,
and Carola Zelaschi.

Naama Tsabar.
Transitions #4

April 20–July 16, 2018
Curated by Ines Goldbach

Kunsthaus Baselland
St. Jakob-Strasse 170
Muttenz / Basel, Switzerland
kunsthausbaselland.ch

Director and Curator
Dr. Ines Goldbach
Director's and Exhibition Assistant
Patricia Hug-Roditscheff
Assistant Education, Press and Publication
Ines Tondar
Exhibitions Technicians and Education
Oliver Minder (Head of Exhibition Technique)
Sylvain Baumann, Adam Bagnowski,
Dorian Sari
Exhibition Education
Katharina Anna Wieser

Kunsthaus Baselland is supported by
kulturelles.bl; Migros Kulturprozent;
burckhardt+partner; the Jacqueline
Spengler Stiftung; Anthony Vischer;
Gemeinde Muttenz.

The exhibition was supported by the
Artis Grant Program; the Dr. Georg und
Josi Guggenheim Stiftung; the Ostrovsky
Family Fund (OFF); the Ruth und Paul
Wallach Stiftung; the Isaac Dreyfus-
Bernheim Stiftung; Páramo, Guadalajara
(Mexico); Kasmin, New York; Dvir
Gallery, Tel Aviv / Brussels; Spinello
Projects, Miami.

Transitions #4, composed and performed
by Anna Erhard, FIELDED, Kristin
Mueller, Sarah Strauss, Naama Tsabar,
and Anja Waldkircher.

Naama Tsabar.
Melody of Certain Damage (Opus 3)

December 22, 2018–February 9, 2019
Curated by Chen Tamir

CCA – Center for Contemporary Art
Tel Aviv at the Rachel & Israel Pollak
Gallery, 2a Tsadok Hacohen St.
Tel Aviv 6525620, Israel
cca.org.il

Board of Directors
Sergio Edelsztein (Chairman), Gil Brandes,
Benno Kalev, Giora Kaplan, Nathalie
Mamane-Cohen, Jacob Peres, Michelle
Pollak, Thomas Rom, Iris Rywkind Ben
Zour, Rivka Saker, Marc Schimmel, Amos
Schocken, Shalom Shpilman, Itay Talgam
Director
Nicola Trezzi
Curator
Chen Tamir
Producer
Diana Shoef
Office Manager
Eyal Agivayev
Public Relations Manager
Karen Dolev
Technical Manager
Dan Owen
Educator
Eden Bannet

CCA – Center for Contemporary Art
Tel Aviv is supported by the Ministry of
Culture and Sport – Visual Arts Department;
Tel Aviv Municipality – Culture and Arts
Division; UIA – the United Israel Appeal;
IL.Collection; Rivka Saker and Uzi
Zucker; The International Council.

The exhibition was supported by Thomas
Rom; Shulamit Nazarian, Los Angeles;
OUTSET Israel; the Mifal HaPais Council
for the Culture and Arts. Additional support
has been provided by Giora Kaplan and
Marc Schimmel. Special thanks to Noor
and Dalton Winery.

Melodies of Certain Damage (Opus 3),
composed and performed by Rotem
Frimer, Nina Loeterman, Maya Perry,
Moran Victoria Sabbag, Sarah Strauss,
and Naama Tsabar.

Published and distributed by
Mousse Publishing
Contrappunto s.r.l. Socio Unico
Corso di Porta Romana 63
20122, Milan–Italy

Available through
Mousse Publishing, Milan (mousse-
publishing.com); DAP | Distributed Art
Publishers, New York (artbook.com);
Vice Versa Distribution, Berlin (viceversa-
artbooks.com); Les presses du réel, Dijon
(lespressesdureel.com); Antenne Books,
London (antennebooks.com)

Edited by
Nicola Trezzi and Naama Tsabar
Publishing Editor
Isabella Zamboni–Mousse
Editorial Coordinator
Benedetta Pomini–Mousse
Copyediting
Anne Ray
Book Design
Luigi Amato–Mousse

First edition: 2019
Printed in Italy by Ediprima srl

ISBN 978-88-6749-402-6
EUR 22 / USD 25

FAENA ART KUNSTHAUSBASELLAND CCA

 BancoCiudad
 KULTURELLES.BL
BILDUNGS-, KULTUR- UND SPORTDIREKTION
 MIGROS
kulturprozent
 burckhardtpartner

 JACQUELINE SPENGLER STIFTUNG
Anthony Vischer
 Gemeinde Muttenz
 משרד התרבות והספורט
 TEL AVIV YAFO

 DS AUTOMOBILES
 EMBAJADA DE ISRAEL EN ARGENTINA
 artis grant program
 DR.GEORG UND JOSI GUGGENHEIMSTIFTUNG
Ruth und Paul Wallach Stiftung

 isaac dreyfus bernheim
FONDATION/STIFTUNG
 OSTROVSKY FAMILY FUND
 outset.
 Israel Lottery Council for the Arts

 גלריה דביר DVIR GALLERY
KASMIN
 ShulamitNazarian LosAngeles
 PÁRAMO
Spinello

MOUSSE PUBLISHING